The Color of
Nature

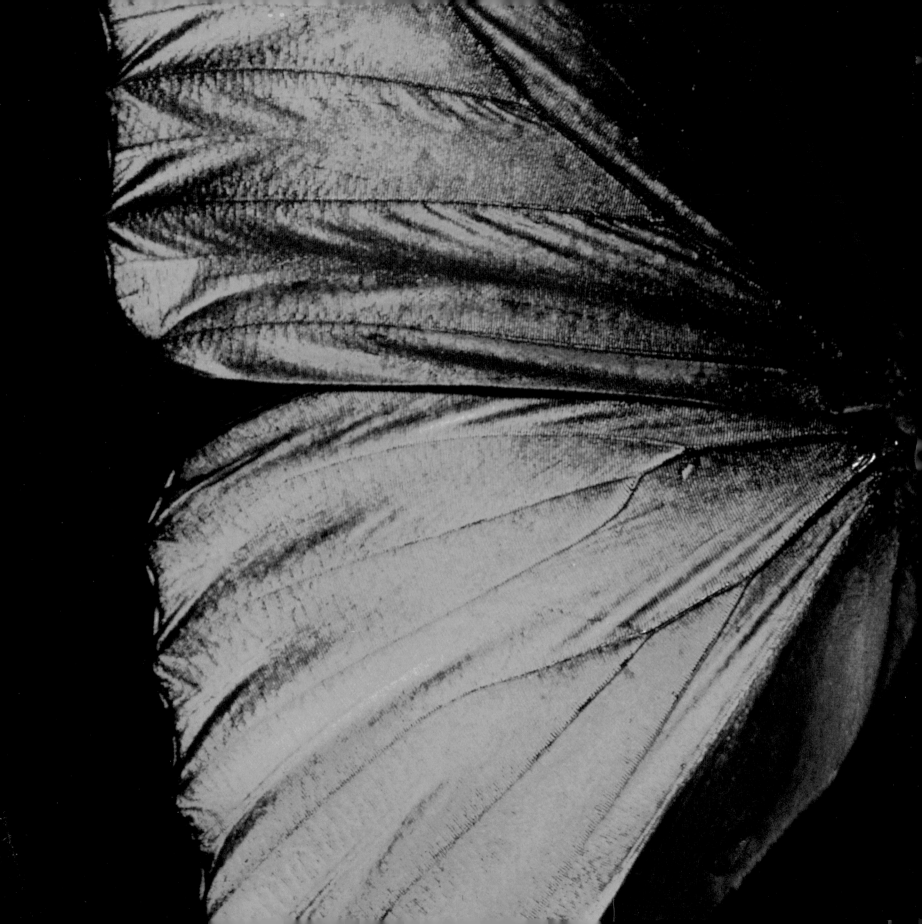

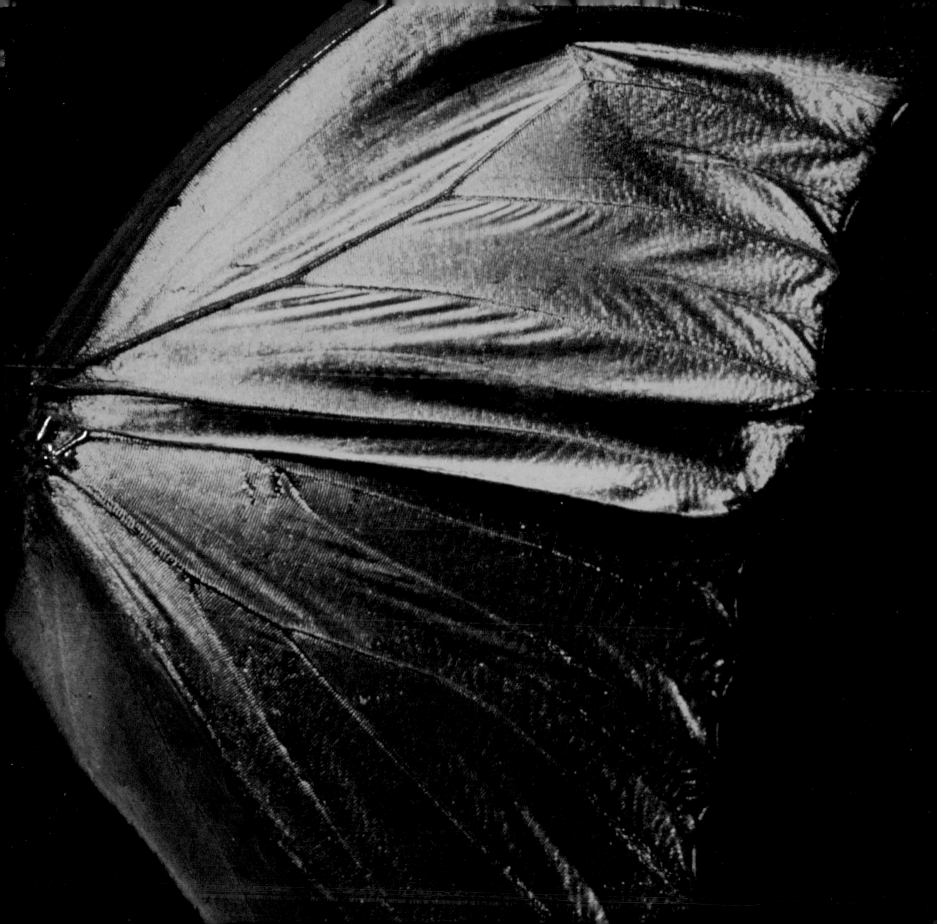

The Color of
Nature

By Pat Murphy and Paul Doherty

**Featuring photography
by William Neill**

An Exploratorium Book

CHRONICLE BOOKS / SAN FRANCISCO

Design by push, San Francisco

Photo on pages 2–3: Blue Morpho Butterfly by William Neill
Photo on page 11: Grasses, Wind River Mountains, by William Neill

Printed in Hong Kong

Library of Congress Cataloging-in-Publication Data:

Murphy, Pat, 1955-
 The color of nature / by Pat Murphy, Paul Doherty,
 and William Neill [photographer].
 p. cm. — (Exploratorium book)
 Includes bibliographical references and index.
 ISBN 0-8118-1357-6
 1. Color. 2. Clouds—Pictorial works. 3. Color—Pictorial works.
I. Doherty, Paul. II. Neill, William. III. Title. IV. Series.
QC495.M9 1996
535.6—dc20 95-53863 CIP

Distributed in Canada by
Raincoast Books
8680 Cambie Street
Vancouver, B.C. V6P 6M9

10 9 8 7 6 5 4 3 2 1

Chronicle Books
275 Fifth Street
San Francisco, CA 94103

To all staff and friends of the Exploratorium,
the museum that changed the way we see the world.
—Pat Murphy and Paul Doherty

For all the explorers and artists who search for knowledge and beauty.
—William Neill

Contents

Steady
Red Roses and Pink Flamingos
19

Glowing
Distant Stars and Flowing Lava
55

Pleasures

by Denise Levertov

I like to find
what's not found
at once, but lies

within something of another nature,
in repose, distinct.
Gull feathers of glass, hidden

in white pulp: the bones of squid
which I pull out and lay
blade by blade on the draining board—

 tapered as if for swiftness, to pierce
 the heart, but fragile, substance
 belying design. Or a fruit, *mamey,*

cased in rough brown peel, the flesh
rose-amber, and the seed:
the seed a stone of wood, carved and

polished, walnut-colored, formed
like a brazilnut, but large,
large enough to fill
the hungry palm of a hand.

I like the juicy stem of grass that grows
within the coarser leaf folded round,
and the butteryellow glow
in the narrow flute from which the morning-glory
opens blue and cool on a hot morning.

Introduction by Paul Doherty

Twenty years ago, I was hiking up Mount Monadnock in New Hampshire when I glanced up through the trees to see the colors of an oil slick spread through the clouds. I stopped in my tracks and studied the sky. The clouds were candy-striped with alternating bands of pastel green and pink. As I watched over the next hour, the cloud matured and the colors changed. The bands of color became wider, then narrower. Eventually, as the clouds thickened, the colors faded away.

These colorful clouds, I later learned from reading and talking with my physics professors, were called iridescent clouds. Their colors came from sunlight scattering through water drops of uniform size.

It was interesting to learn what caused the colors—but what I found surprising was that I had never noticed these colors in the sky before. After my first sighting of the clouds over Mount Monadnock, I began to watch for iridescent clouds and discovered that they are quite common. I now see iridescent clouds twenty times a year or more. Since I was twenty years old the first time I saw these colors, I had missed seeing them at least four hundred times as I grew up. These fabulous colors had always been there—hidden in plain view, spread across the sky. The colors had been there, but I hadn't seen them.

Over the years, as a physics professor and a mountaineer, I've learned to notice and observe changing colors in the sky. Many people think of physics as a discipline that requires an extensive understanding of mathematical equations and a collection of complex equipment—and some physics is like that. But physics of any kind begins with seeing and noticing and wondering why. The first step to understanding is seeing the world and seeing it clearly.

Consider, for example, the color of the sky. Do you remember what color the sky was in the fall of 1991? How does that compare with the color of the sky today?

In 1991 Mount Pinatubo in the Philippines erupted. The high, thin clouds of sulfuric acid drops that the eruption sent into the Earth's stratosphere added white light to the blue light scattered by air molecules. For the next two years, the sky over North America was a pale, washed-out blue, rather than a deep, pure color.

Abalone Shell / William Neill

The mother-of-pearl coating that lines the inside of an abalone shell is made up of layers of calcium carbonate with water sandwiched between them. Light reflecting from these layers produces iridescent colors.

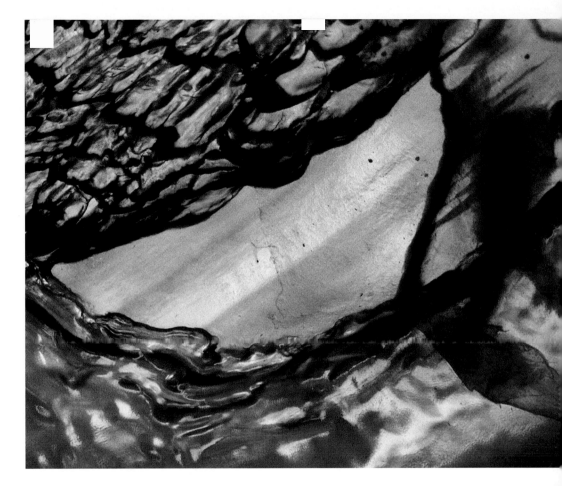

Most of my friends didn't notice the change in the sky's color until I pointed it out. They hadn't learned to read the sky for subtle changes that told of atmospheric events. They had—as most of us do in our busy lives—learned to ignore things that didn't change. The sky was blue—they knew that—and they didn't bother to check and see if that color had changed from day to day. But once I pointed out the change, they noticed and appreciated it, watching and waiting with me as the stratosphere became clean once again and deep blue skies returned.

When I'm not watching the sky, I'm a teacher at the Exploratorium in San Francisco, a museum dedicated to helping people notice things that they usually overlook. The museum is filled with exhibits that allow people to explore and experiment with natural phenomena. At the Exploratorium, visitors can create miniature lightning bolts, study the colored light given off by glowing gases, and play with a captive tornado. At the *Colored Shadows* exhibit, they can mix red light and green light to make a startling yellow. At the *Benham's Disk* exhibit, they can observe colored lines on a spinning black-and-white disk, an optical illusion created by the color-sensitive cells in the eye.

Part of my job at the Exploratorium is educating teachers and museum visitors and helping them learn to see interesting phenomena, like iridescent clouds and the changing color of the sky. I watch people experiment with the museum's exhibits, and I share my insights about those exhibits. And, more often than not, I learn new things about our exhibits from visitors' questions and from the discoveries they make while experimenting.

Colors on a Car Windshield / William Neill

If you pay attention, you'll discover colors where you least expect them. While taking pictures for this book, photographer William Neill noticed these colors smeared across his windshield by the wiper blade. The colors are reflecting from a thin film of oil on the glass. The same process that creates these colors produces the colorful sheen of an abalone shell, the shimmering colors of a soap film, and the brilliant iridescence of a peacock's tail feathers.

The work that I do at the Exploratorium has spread to fill my life. In fact, I find it hard not to get enthusiastic about sharing all the colors I see. Over the years, I've found that pointing at the sky is one effective way to call people's attention to celestial colors. Often the setting sun is accompanied by sun dogs, colorful patches to either side of the sun made by ice crystals high in the atmosphere. In parking lots and at the beach, I enjoy pointing sun dogs out to people I meet. I show the phenomenon to one group of people, then step back and watch as the pointing spreads. One person will share the sky color with another, who will share it with several more people, in a chain reaction of observation.

Of course, my enthusiasm for sharing nature's colors with others sometimes gets the better of me. While sleeping out in a Yosemite campground, I opened my eyes to see a bright arc of colors through the trees straight overhead. This colored arc curved upward, like a smile. It was a circumzenithal arc, one of the most brightly colored of nature's celestial displays. I lay still for a moment, appreciating the rare phenomenon from the comfort of my sleeping bag. But my desire to capture an image of the arc that I could share with others prevailed, and I dashed to the car to grab my camera. As I pointed the arc out to my friends in the campsite, they showed me something that I hadn't noticed. Rather than gazing up at the sky, the other campers were pointing at me as I ran about, scantily clad in the cold morning air.

But a momentary embarrassment can't diminish my enthusiasm for the colorful world around us. Even after years of looking, I still see new colors. Walking at the seashore, I expect to see the opalescent colors that line an abalone shell, but I'm startled to see the iridescent sheen of a broad leaf of seaweed. On a snowy Sierra Nevada slope, I use my ski pole to poke a hole in a snowdrift, revealing a glowing blue interior. Or I pause by an alpine lake to admire its brilliant turquoise-blue color.

When I see a color I have never seen before, I watch it for a while. I savor it, observe how it changes when I look at it from different angles or against different backgrounds.

Iridescent Clouds, Jasper National Park, Alberta, Canada / William Neill

The colors in these clouds come from light scattering from small, uniform water drops in high, thin clouds. Though most people have never noticed colored clouds like these, they are not rare.

As a physicist I've learned what creates these colors—a story that reveals a few things about the nature of the light that carries these colors to your eyes. In this book, Pat Murphy and I have described the science behind the colors—explaining why the hole in the snow is blue, why the abalone shell glistens with color, why the water of a lake formed by a melting glacier may be a brilliant turquoise blue. But understanding why is the second step. First, you must learn to look.

This book is my way of standing next to you and pointing out the colors in nature, with the help of the colorful images captured by William Neill and other talented nature photographers. I hope that these photographs and the accompanying text will open your eyes to colors you haven't seen before, from the iridescent sheen in the wings of a fly to the colors of distant nebulae and stars.

I also hope that this book will help you take the time to study the colors you see, looking beyond what you notice in your first glance. A rainbow—the symbol of all that is colorful—is beautiful, but studying the rainbow brings a deeper appreciation of that beauty. When I see a rainbow, I study it and watch it change, knowing that the intensity of the colors and the width of the stripes of color depend on the size of the raindrops. As the drop size changes, the rainbow changes too. The rainbow is a story in the sky waiting to be read, and it takes some time to read and appreciate that story.

Burnt Trees and Shadows on Snow / William Neill

Next time you're out in the snow on a sunny day, take a close look at the shadows around you. Usually, we think of shadows as black. They are, after all, places where something is blocking the light, leaving a patch of darkness. But under the right circumstances, shadows can be colored by light from another source. On this snow-covered slope, light from the blue sky fills in the shadows.

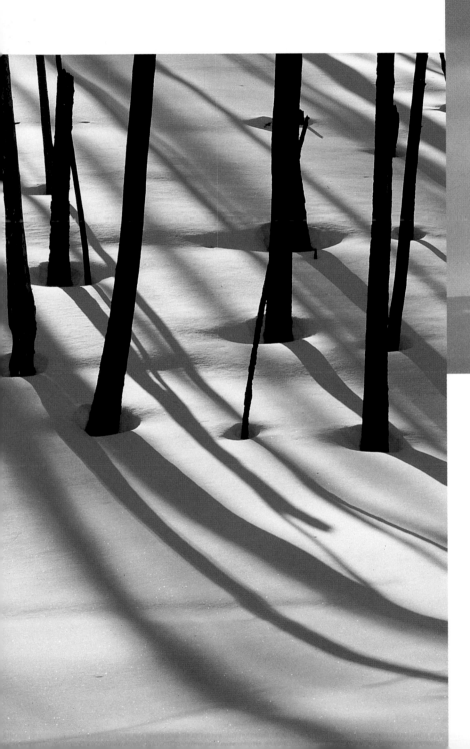

**Double Rainbow, Bryce Canyon
National Park, Utah** / William Neill

Have you ever noticed that the sky
is bright inside the rainbow's arc and
darker outside? Most of the light
reflecting from the raindrops ends up
inside the rainbow's arc, making this
area of sky bright. If you study a rain-
bow carefully, you can often see a
fainter secondary rainbow outside the
bright primary rainbow.

Steady colors

1

Red Roses
and Pink
Flamingos

When spring comes to California, the hills are abloom with color. Stalks of blue lupine stand high above the green grasses and leaves.

California poppies and goldfield brighten rocky slopes. In wetter areas, yellow buttercups and orange monkeyflowers are bright against the lush greenery.

Some of the insects that visit the California hillsides are as colorful as the flowers themselves. An orange-and-black monarch butterfly flutters from blossom to blossom. Boldly striped bumblebees, honeybees, and other buzzing insects visit the flowers one by one, collecting pollen from each.

Why are the wildflowers and insects of a California meadow so colorful? The white sunlight that shines on the meadow contains all the colors of the rainbow. The colors that you see in the plants and animals come from pigments, chemical compounds that absorb some of those rainbow colors and reflect the others. Lupine blossoms are blue because they contain anthocyanins, pigments that reflect blue light and absorb other colors. The green of grass and leaves comes from chlorophylls, pigments that reflect green.

Pigments reflect colored light, but that's not the end of the story. To have color, you need light—and you also need eyes that can detect light and distinguish one color of light from another.

When you are looking at a sunlit meadow, the light that reflects from the lupine blossoms, the green leaves, and all the other plants and insects enters each of your eyes, shining in through the pupil, the dark hole in the center of the iris. The lens of your eye focuses this light to make an image on the retina, a layer of light-sensitive cells at the back of your eye. The light shining on the retina stimulates the cones, the cells that distinguish among different colors of light. The cones send a message, via the optic nerve, to your brain. Your brain interprets this message, and you see the meadow, in all its colorful glory.

The meadow is colorful because plants and animals produce pigments and because your eyes detect the light that these pigments reflect. But this leads to another question: Why do plants and animals produce the pigments that color the natural world?

A few pigments have vitally important physiological functions. The chlorophylls that make plants green, for example, are necessary for photo-

◄ **Red Roses** / William Neill

Some flowers that look plain to human eyes have markings that reflect ultraviolet light. Under visible light, the petals and stamens of this evening primrose flower are a uniform shade of yellow. But photographed under ultraviolet light, the center of the flower is dark, marking where insects must go to find the flower's nectar and pollen. Though humans can't detect these ultraviolet markings, bees and other insects can.

Evening Primrose Photographed by Visible Light / Heather Angel

Evening Primrose Photographed by Ultraviolet Light / Heather Angel

synthesis, the conversion of water and carbon dioxide to sugars and oxygen. This process provides the chemicals required to support life on Earth. But most of the pigments that color the meadow don't serve such a direct physiological role. Instead, they are signals, colorful communications from one organism to another.

For the most part, these brilliant dispatches aren't intended for human eyes. We see and appreciate the color, but the message passes us by.

Take, for example, the colorful wildflowers. All those brightly colored blossoms are shouting the same message over and over. The message is simple: "Come pollinate me now! You can get some nectar or pollen here if you come pollinate me now!"

If a flower's message is answered, the plant wins, and the prize is reproduction. Winning plants attract animals that carry pollen from one plant to another, a process called cross-pollination. Though many flowers can be fertilized and produce seeds with their own pollen, cross-pollination offers certain evolutionary advantages. Since the seeds that come from cross-pollination inherit traits from both parent plants, the resulting popula-tion is more genetically diverse and more likely to include individuals that will survive in times of changing environmental conditions.

Each wildflower's simple message is directed at very specific animals. Consider the honeybees that buzz from flower to flower, sipping nectar and collecting pollen. Over millions upon millions of years of evolution, some of the flowers in the meadow have adapted to attract the attention of these buzzing insects, and the honeybees have adapted to serve the needs of the flowers that provide their food.

Color is one way to attract a honeybee's attention. For centuries, beekeepers have helped bees find their way home by using color to mark hives set close together. Twentieth-century experimenters confirmed what the beekeepers knew: bees see in color.

That doesn't mean that bees see the same colors that you and I see. In fact, experiments have shown that they don't. For humans, the visible spectrum begins with red, proceeds through shades of orange, yellow, green, blue, and indigo, then ends with violet. Unlike humans, honeybees can't detect red. The bee's visible spectrum begins with orange-yellow, proceeds through shades of yellow, green, blue, indigo, and violet, then continues into ultraviolet, a color that human eyes can't detect.

If you watch the bees in a meadow closely, you may notice that they don't visit flowers of different plants with equal frequency. They favor certain blossoms, ignoring others. Studies have indicated that some colors attract bees more than others. A honeybee's favorite color is ultraviolet, and her least favorite color is blue-green. Since bees don't see red, this color is rare among the flowers that rely on bees for pollination. In fact, bee-pollinated flowers that look red to us humans may have other attributes that are hidden from our eyes. The European corn poppy, for example, a brilliant red flower commonly pollinated by bees, reflects ultraviolet light, attracting bees with a color that our eyes can't detect.

Each wildflower has evolved a color, a scent, and a structure to attract a specific type of pollinator. Bumblebees are attracted to blues, violets, and purples; hoverflies like yellow. Unlike bees, some species of butterflies can see red. Flowers that attract butterflies are often red and frequently provide a platform where a butterfly can land. Nectar-sipping birds, like the hummingbird, have eyes that are more sensitive to red than to blue and violet, and are attracted to red and reddish yellow blossoms.

Like the wildflowers, the animals that pollinate them have evolved pigments to improve their chances of surviving and reproducing. Perhaps the most prevalent use of color is for camouflage. By blending in with their background, these animals conceal themselves from potential predators or potential prey. Rather than shouting a message, these animals are trying to erase their visual presence: "Don't notice me. I'm not here."

If camouflage were the only purpose for animal coloration, the world would be a much duller place. But like the flowers in the meadow, some animals use conspicuous colors to call attention to themselves and send a message. The monarch butterfly has bright orange-and-black wings, a highly visible color pattern that warns predators to keep away. Monarch caterpillars feed on milkweed, which produces cardiac glycosides, chemicals that can be toxic to vertebrates. The caterpillars accumulate these chemicals in their body tissue. When the caterpillar changes into a butterfly, it retains these toxic chemicals. A bird that eats a milkweed-fed monarch butterfly tastes something nasty and often vomits. One or two such experiences are usually enough to convince a bird to avoid this brightly colored insect.

Rather than hiding from predators, animals that have chemical defenses and dramatic warning colors tend to make themselves conspicuous. The South American poison arrow frog moves sluggishly and rests in the open, protected from predators by its poisonous skin secretions. The spotted skunk of North America does not flee when threatened. Instead, the animal lifts its plumelike tail and stands on its hands to display its striking coloration before releasing its noxious stink.

Unrelated animals that make use of chemical defenses may display similar patterns of warning colors. For example, hornets, some species of wasps, and the poisonous caterpillars of the cinnabar moth are striped in shades of yellow and black. In 1878, German zoologist Fritz Müller suggested an explanation for this similarity. He noted that predators learn to avoid prey species by sampling them—and that a few members of the prey species may die in the predator's learning process. A toad that eats a hornet gets stung and learns to avoid hornets, but that one unfortunate hornet gets eaten before the toad learns its lesson. By adopting similar colors, prey species minimize the number of their fellows who die in the learning process. Once a toad has learned to avoid eating hornets, it will tend to avoid the other species with similar color patterns, thus minimizing predation on yellow-and-black wasps and cinnabar moth caterpillars.

But evolution can be sneaky. Some animals have taken advantage of the protection conferred by warning colors—without developing the defenses to go with them. The robber fly, which lacks the hornet's sting, is boldly striped in black and yellow, very much like a bee or hornet. Toads that have eaten hornets, getting stung in the process, won't even sample a robber fly.

Warning colors communicate from one animal species to another. Bright colors may also send a message to an animal's potential mates and rivals of the same species. The robin's red breast, for example, advises other male robins to stay away. During the breeding season, a male robin will attack a tuft of red feathers placed in his territory, reacting to the red color.

Flowers of different colors tend to attract different insects. Bumblebees are attracted to blues, violets, and purples, and hoverflies like yellow. Butterflies often prefer red flowers that provide a platform where the insect can land. The honeybee's favorite color is ultraviolet, a color that human eyes can't detect.

Wildflowers in Field, Merced River Canyon, Sierra National Forest, California / William Neill

If a message that's communicated with color is going to be effective, the intended recipient must be able to detect it. Most mammals don't have color vision, which partially explains why the coloration of mammals is somewhat duller than that of birds and insects. Rather than using brilliant colors to make social signals easier to read, mammals more often rely on contrasting shades of light and dark. When an angry lion raises his tail and lashes it back and forth above his back, for example, the dark hair at the tail's tip calls attention to this movement, communicating his mood to other lions in the area.

We humans often think of ourselves as far above the rest of the animal kingdom, but we too use color to communicate. To give its offspring the best chance for survival, an animal strives to choose a healthy mate. Among fair-skinned humans, red lips and ruddy cheeks can be indications of good health. The red comes from hemoglobin, the pigment that colors blood, showing through the skin. Part of the appeal of red lipstick and rouge may be the simulation of the ruddy tones of good health desirable in a mate.

In human communities, people use color to mark themselves as part of a particular group. The Crahó tribe of Brazil paint their bodies with red-and-black patterns that indicate their relationship to other members of the tribe, and sports fans may wear their team's colors to express their support and unity.

With color, we also sometimes communicate in ways that we can't always control. Think of that the next time you blush bright red in embarrassment.

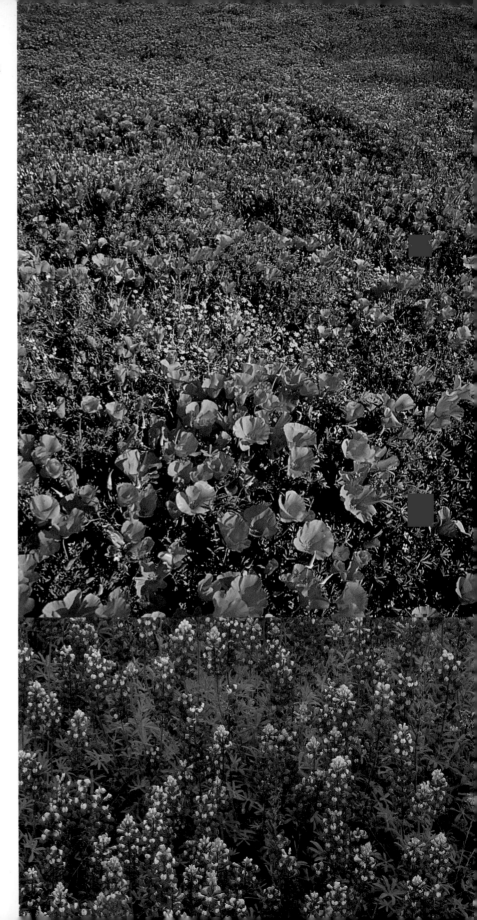

Poppy Fields, Antelope Valley, California / William Neill

If insects were color-blind, these mountain meadows would be much less colorful. Wildflowers have evolved colorful pigments to attract insects and birds that will transfer pollen from one blossom to another.

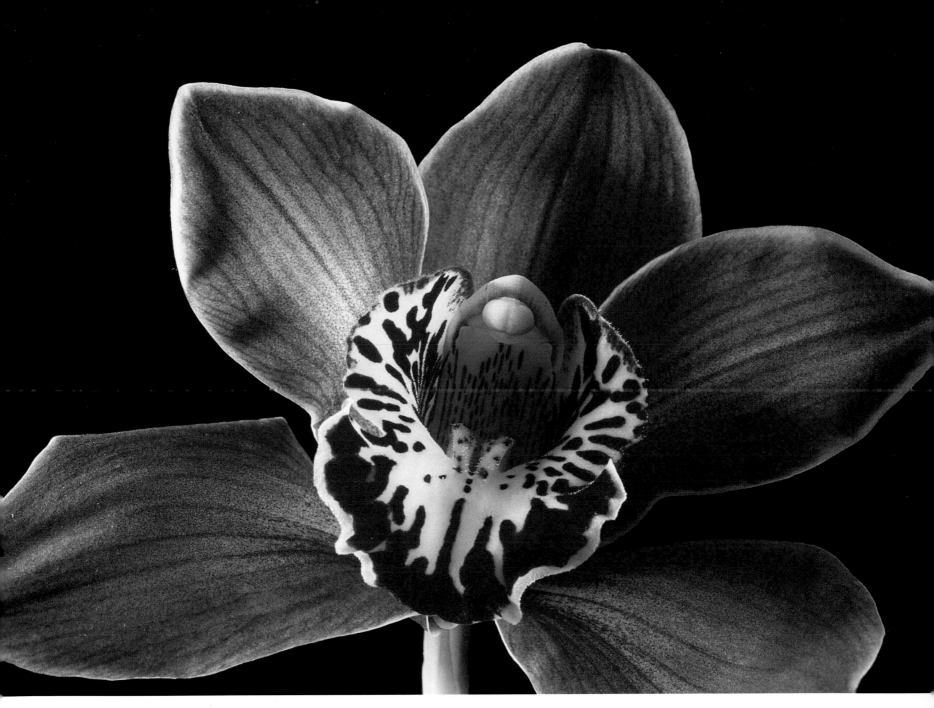

Cymbidium Orchid / William Neill

In 1793, naturalist Christian Konrad Sprengel recognized the significance of the spots and lines and other markings on flower petals. These markings show, Sprengel wrote, "just where the insects must crawl in if they want to reach the nectar." Since Sprengel's time, biologists have confirmed the importance of these markings, noting that they are most likely to be found on flowers with complicated structures and hidden nectar.

Lupine, Yosemite National Park, California / William Neill

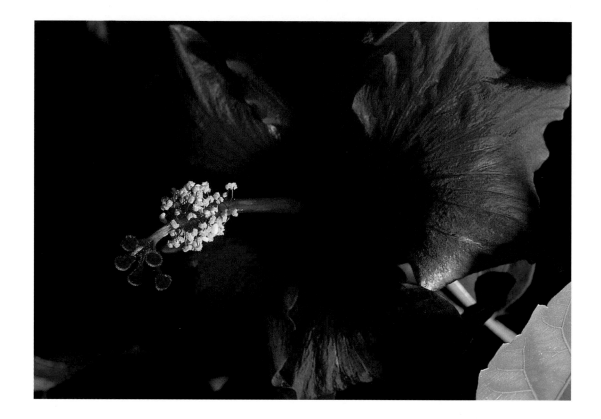

Hibiscus Flower / William Neill

Some flowers, like this hibiscus, are specially adapted to pollination by birds. The scarlet color attracts hummingbirds. When a hummingbird thrusts its beak into the flower to sip the nectar, the flower's pollen-bearing stamens brush against the bird. When the bird visits another blossom, some pollen is brushed off, fertilizing the flower. The blossoms protrude from the foliage, providing the birds with easy access. Since birds generally have little or no sense of smell, bird-pollinated flowers often have a fainter scent than those that attract insects.

Like the hibiscus, the bottlebrush
flower relies on birds to carry
its pollen. Rather than attracting
attention with colorful petals,
the pollen-bearing stamens of the
bottlebrush are bright red. If you
look closely, you can see the
golden grains of pollen at the
end of each stamen.

Bottlebrush Flower / William Neill

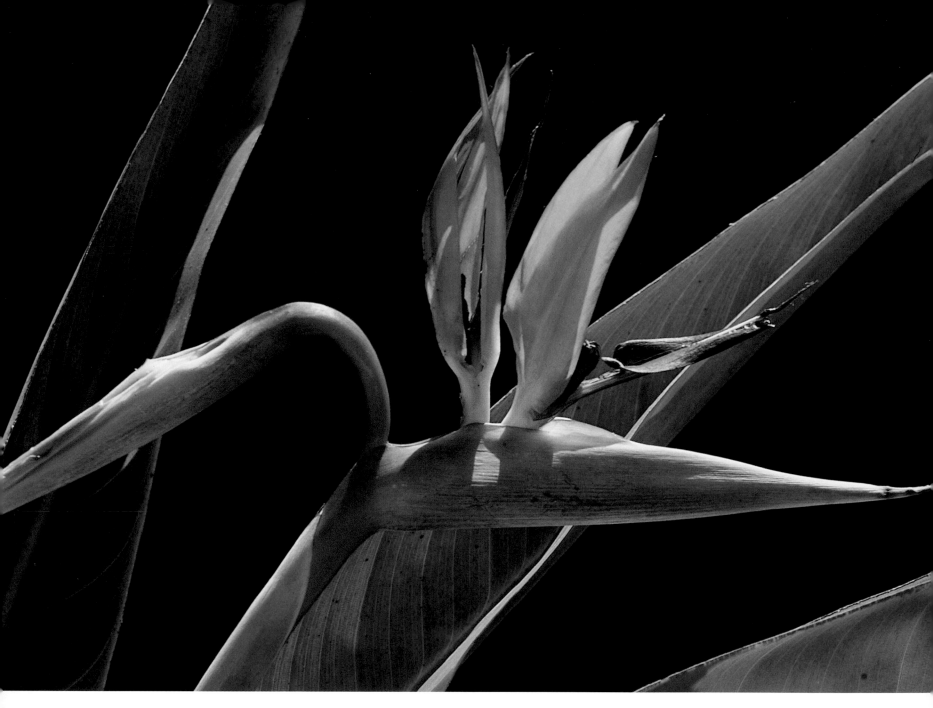

Bird-of-Paradise in Bloom / William Neill

In bloom, the bird-of-paradise looks like the head of a crane

wearing a crest of bright flowers. In its native South Africa, the blossoms are pollinated by sunbirds and sugarbirds that perch on the "bill" of the crane.

As the bird reaches for the nectar that's in the flower, its breast presses against two petals and brushes against the stigma, the part of the flower that must receive pollen if the flower is to produce seeds. This pressure releases the flower's pollen-bearing stamens, which dust the bird's breast with pollen. After this happens, the petal that covers the flower's hidden nectar can be raised. The bird will carry the pollen from one flower to the next one it visits.

Mountain Ash Berries, Clingman's Dome, Great Smoky Mountains National Park, North Carolina / William Neill

Unripe fruits are usually green so that they blend in with the surrounding leaves. As fruit ripens, it often changes color so that it contrasts with the vegetation. These mountain ash berries are red to attract the attention of fruit-eating birds. Birds eat the fruit, fly to new areas, and then excrete the undigested seeds, inadvertently planting mountain ash seeds far from the parent tree.

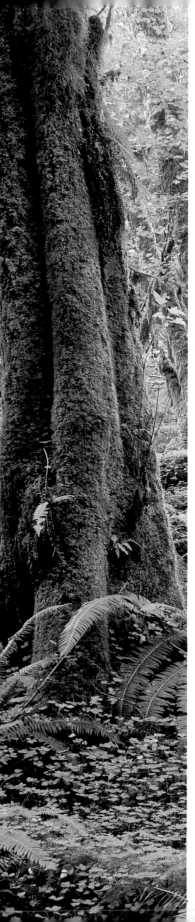

Corn Lilies, Yosemite National Park, California / William Neill

Most plants are green because they contain chlorophylls, pigments that reflect green light and absorb red, yellow, blue, and violet light. Most pigments convert light energy to heat energy, but the chlorophylls are an important exception. These pigments absorb light energy and transfer this energy to neighboring molecules in the process known as photosynthesis. Without the chlorophylls and the chemical transformations they make possible, life as we know it could not exist.

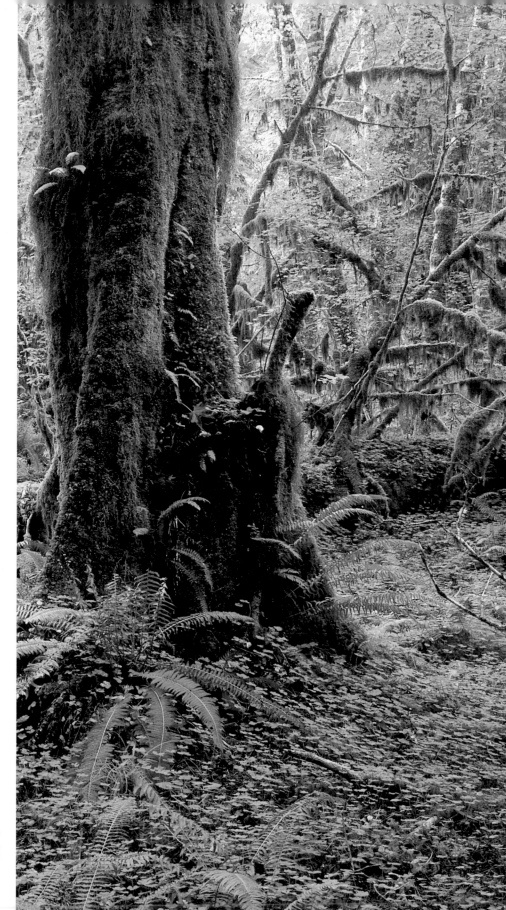

Vine Maples, Sword Ferns, and Sorrel, Olympic National Forest, Washington / William Neill

The painted eucalyptus lacks the protective layer of dead cork cells that gives many trees their rough bark. Patches of its smooth bark are colored bright green by chlorophyll. The presence of chlorophyll indicates that photosynthesis takes place in the trunk of this tree—as well as in its leaves. Photosynthetic bark is most common among trees that grow in arid regions. During the dry season, these trees can lose their leaves and rely on their stems for photosynthesis. Desert cacti, which can be completely leafless, are an extreme example of this adaptation.

Painted Bark Eucalyptus, Island of Maui, Hawaii / William Neill

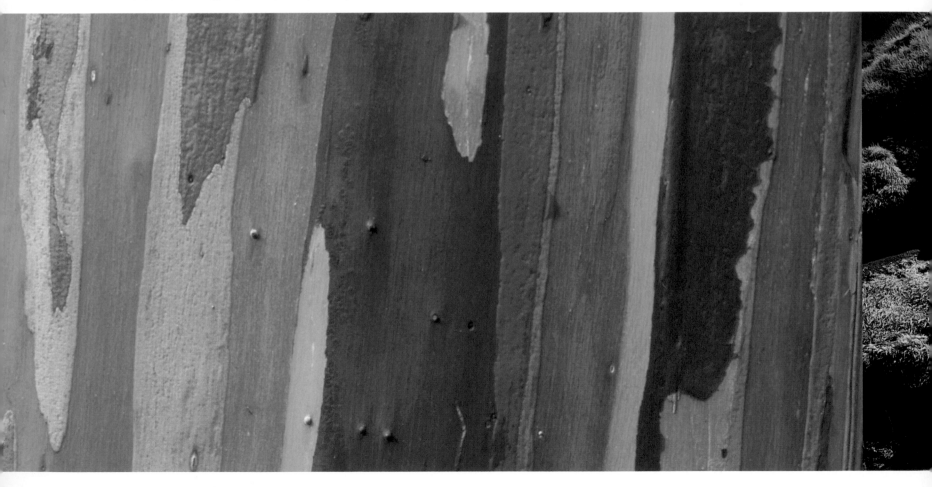

Just after the snow melts, the brilliant red snow plant sprouts in shady areas in the Sierra Nevada. This plant lacks chlorophyll, the pigment that gives most plants their green color, and cannot produce nutrients through photosynthesis. Fungi that coat the roots of the snow plant allow it to obtain its nutrients from decaying matter in the forest soil.

The bright green of chlorophyll usually masks the other pigments that are also present in green leaves. But in the autumn, when chlorophyll decays and turns pale yellow, other pigments show through. Lighting and temperature affect the formation of these pigments. That's why the most dramatic autumn colors develop during the cold, clear, crisp days following a warm summer.

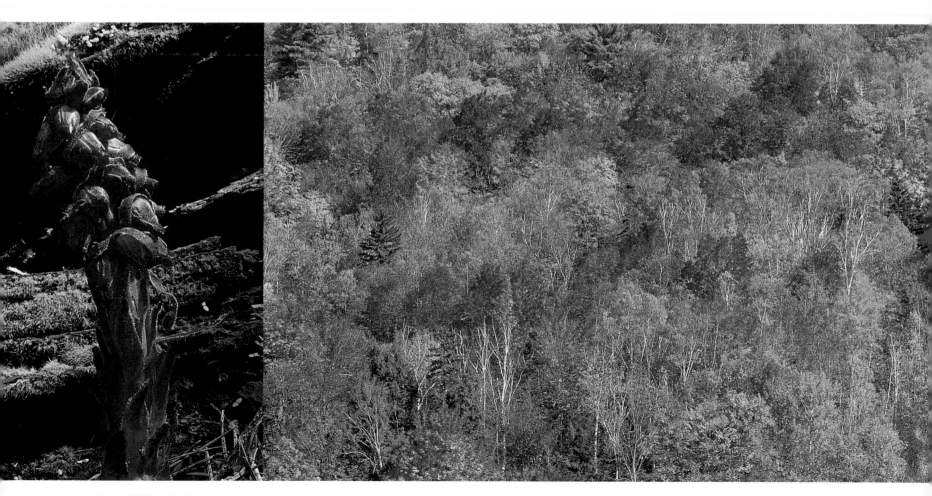

Snow Plant / William Neill

Autumn Hillside, Green Mountain National Forest, Vermont / William Neill

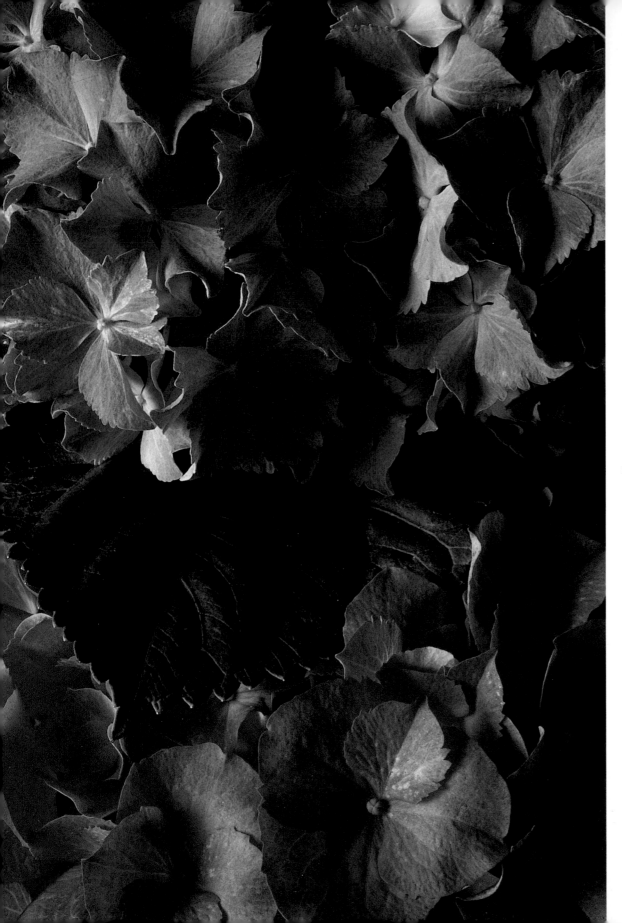

Concord Grapes / William Neill

The pigment that colors these Concord grapes changes color with acidity. Add grape juice to lemonade, and it will turn bright red. Add the same juice to a mixture of baking soda and water, and it will turn blue.

Hydrangea Flowers / William Neill

The same pigment may change colors under different conditions. Many anthocyanins, pigments commonly found in plants, turn red in acid and blue in alkaline conditions. These hydrangeas are colored by the same pigment— but the color of that pigment depends on the composition of the soil.

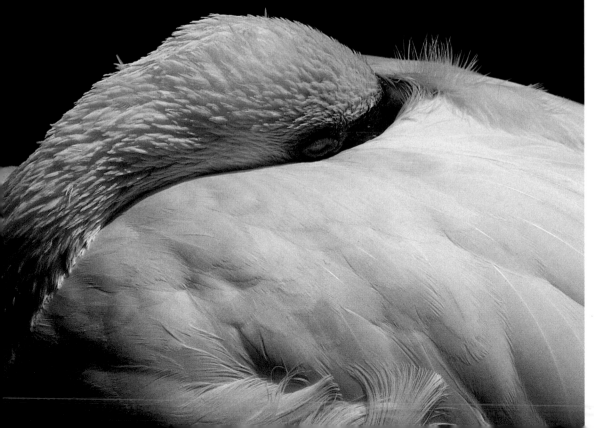

Flamingo / William Neill

Flamingos are pink because their feathers contain carotenoids, pigments that are responsible for many of the reds, oranges, golds, and yellows of plants and animals. Though carotenoid pigments are among the most widespread of animal pigments, animals can't synthesize these compounds but must obtain them from their diet. The yellow color of butter, which comes from a carotenoid, depends on what the cow has been eating; the yellowness of an egg yolk depends on the hen's diet. The pink of the flamingo's feathers comes from pigments in the crustaceans it eats. The crustaceans, in turn, obtain their pigment from algae. If captive flamingos don't get sufficient pigment in their diet, they'll lose their pink color and fade to white.

Lobster, before Cooking / William Neill **Lobster, after Cooking** / William Neill

Living lobsters are green, brown, or blue-green. This color comes from
a carotenoid pigment linked to a protein. When the lobster is cooked,
the bond between the pigment and the protein breaks. Without the protein,
the carotenoid is bright red—and so is the lobster.

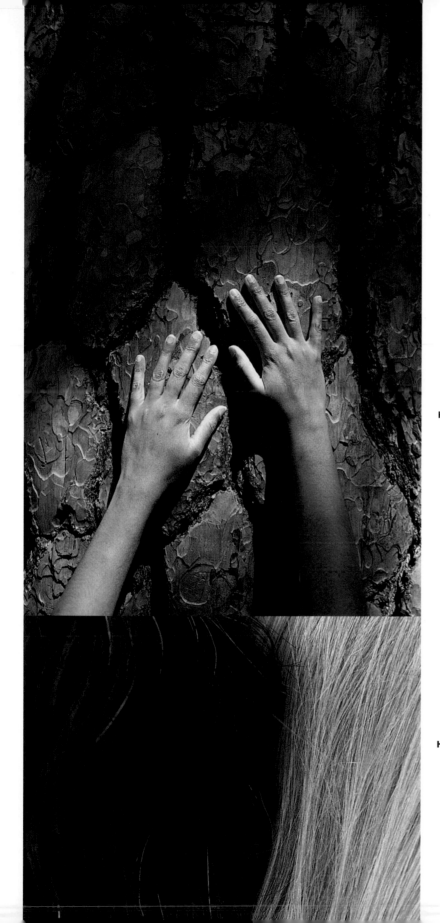

Pigments called melanins are responsible for most of the browns and blacks found in the animal kingdom—including the brown of human skin. The melanin in your skin is found in specialized cells called melanocytes. If your skin is darker than a friend's, that doesn't mean that you have more melanocytes, but rather that your melanocytes produce more melanin.

Human Hands and Ponderosa Pine Bark / William Neill

Exposure to ultraviolet radiation in sunlight stimulates increased melanin concentration, which causes fair-skinned people to freckle or tan. Two days after you're exposed to the sun, specialized cells in your skin begin to produce more melanin. For the next seventeen days, your skin darkens as these cells continue to produce melanin. One month after your time in the sun, the concentration of the newly formed melanin will start to drop, but it takes nine-and-a-half months for your tan to fade entirely.

Human Hair / William Neill

Most mammals are covered with pigmented hair that protects their skin from ultraviolet radiation. In humans, only the head has a protective layer of hair. Dark hair contains more melanin than blond hair. Red human hair contains a unique iron-containing pigment called trichosiderin. The red hair of other mammals does not contain this pigment.

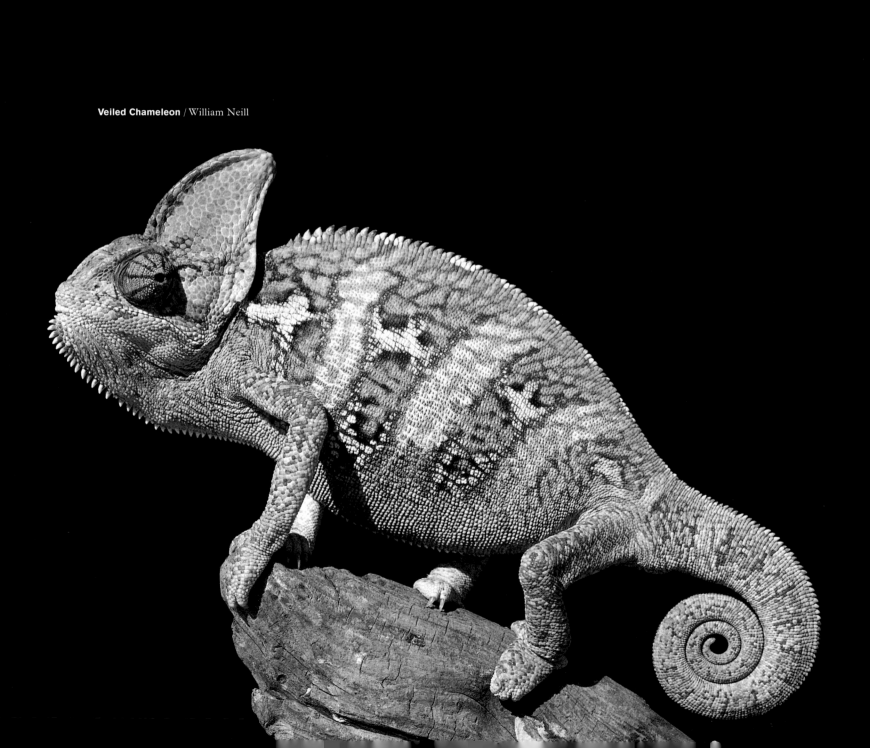

Veiled Chameleon / William Neill

Casque Head Chameleon / Art Wolfe

Chameleons change color by changing

the distribution of a dark pigment in special
branched cells known as chromatophores.
The pigment can be concentrated in the
center of the cell, letting the animal's other
colors show. Or the pigment can spread
out into the branches of the cell, covering
a wide area and causing the reptile's skin
to darken. The color-change is stimulated
by what the animal sees around it. The
chameleon's most dramatic color-changes
are displays intended to defend territory,
court a mate, or frighten away a predator.
Chameleons also change color to match
their surroundings, like this casque head
chameleon on a tree trunk.

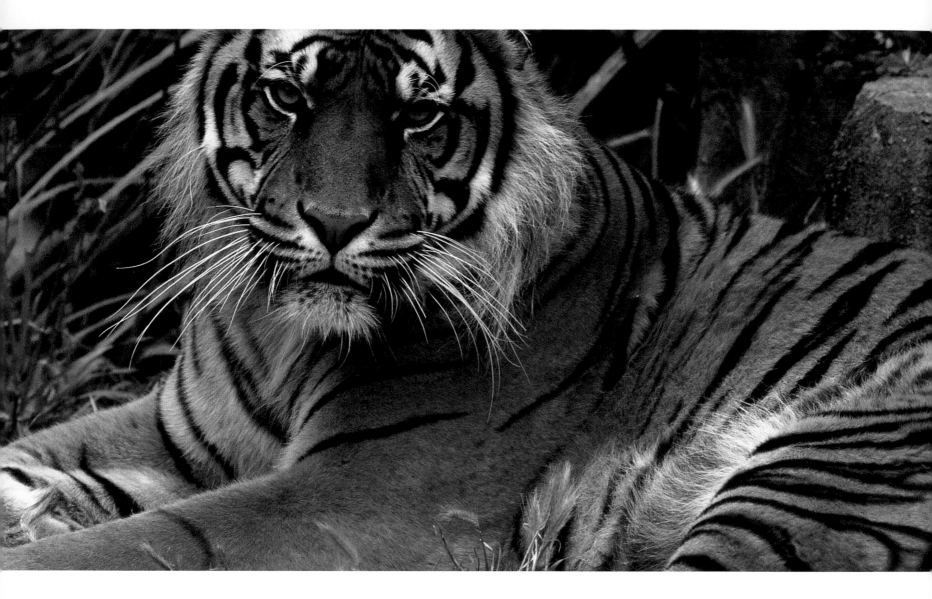

Sumatran Tiger / William Neill

Many animals rely on camouflage to conceal themselves from predators or from their prey.
Patterns of contrasting colors—like the tiger's bold stripes—break up the animal's outline and
disguise its overall shape, a type of camouflage known as disruptive coloration. If this tiger
were all orange or all black, the animal would show up clearly against almost any background.

Each winter, thousands of North American
monarch butterflies migrate to Pacific Grove, California.

Their bold orange-and-black coloration warns would-be predators that these insects are protected by a chemical defense. Monarch caterpillars feed on milkweed plants. Many species of milkweed contain cardiac glycosides, chemical compounds that are toxic to vertebrates. The caterpillars accumulate these foul-tasting chemicals in their body tissue and retain them when they change into butterflies. A bird that eats a milkweed-fed monarch butterfly gets a dose of this poison and often vomits. A few such encounters convince a bird to avoid this brightly colored insect.

Monarch Butterflies / Ron Sanford

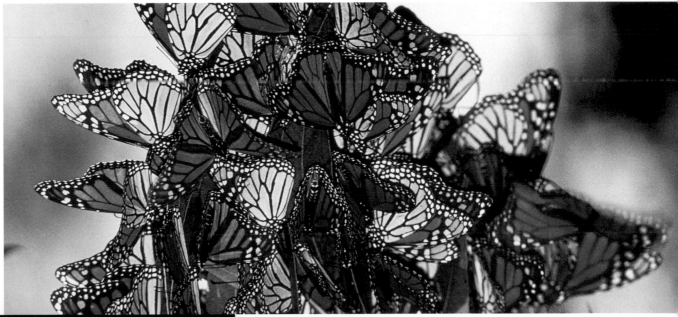

Viceroy Butterfly / William Neill

This viceroy butterfly looks enough like a monarch butterfly to fool a hungry bird. Not only does the viceroy butterfly look like a monarch, it also imitates the monarch's leisurely floating flight. The viceroy butterfly is not poisonous, but birds that have learned to avoid the bad-tasting monarch butterfly will also avoid this mimic.

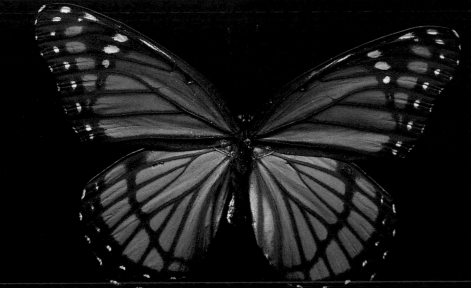

41

Ladybugs / William Neill

The bright red of the ladybug warns predators away. When attacked, these familiar insects discharge noxious fluid from pores around their leg joints. Many animals with warning colors make themselves even more conspicuous by gathering in large groups. Ladybugs congregate to sleep during cold spells or hot, dry weather. When the insects form a cluster, their conspicuous colors reinforce each other, presenting would-be predators with a clear visual warning.

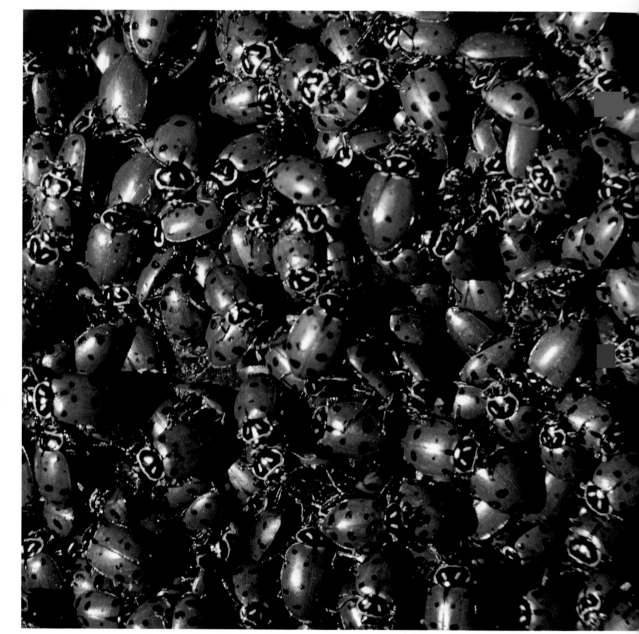

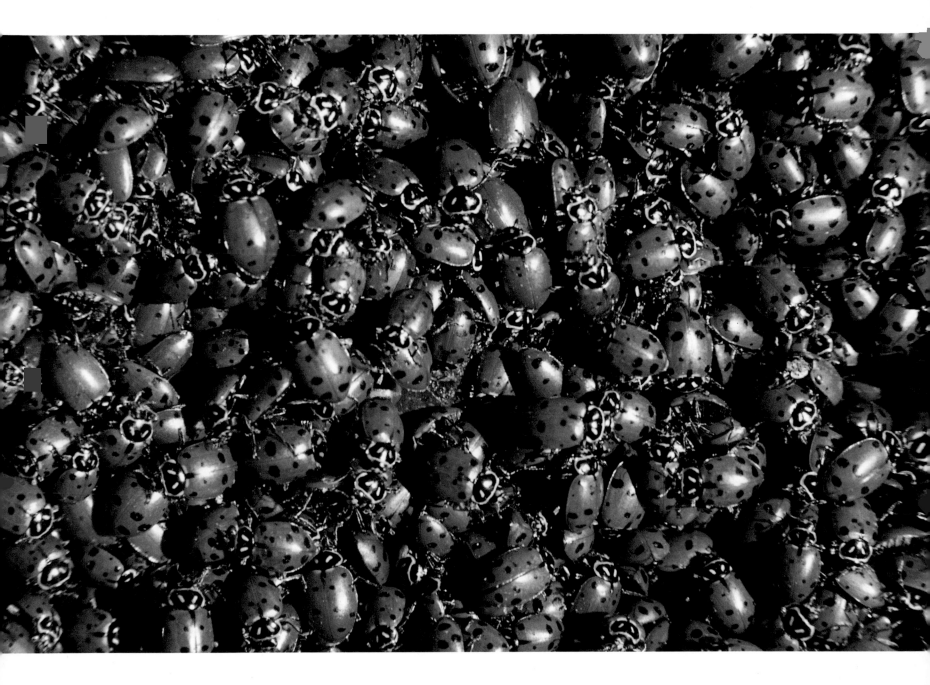

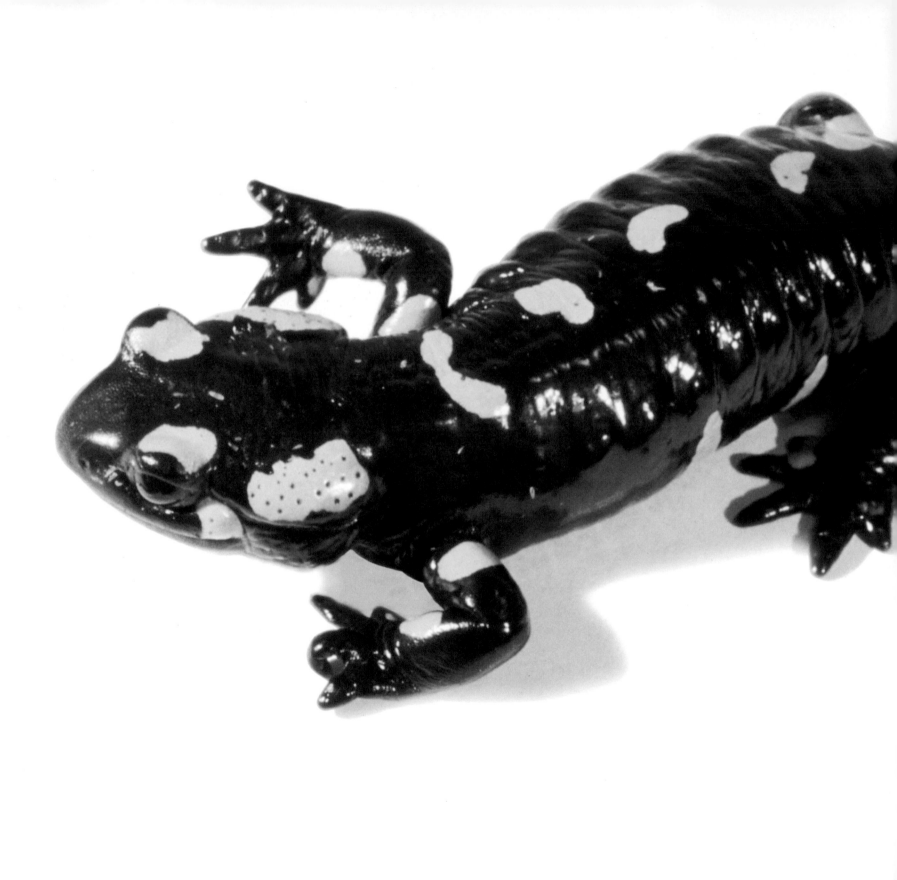

Fire Salamander / William Neill

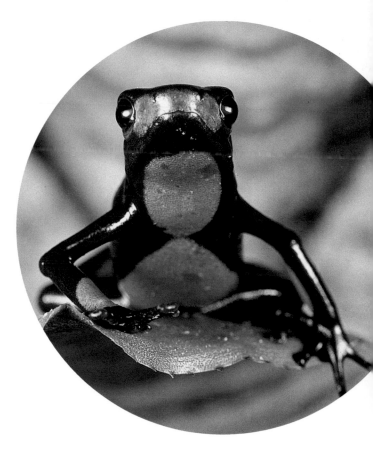

Poison Arrow Frog / Art Wolfe

The brightly colored poison arrow frog

and the European fire salamander warn would-be predators
of their toxicity with bright colors. Like many animals that
rely on warning coloration for protection, these animals are
sluggish and slow-moving, often resting in exposed places.

The colorful soils of Artist's Palette are made up predominantly of iron-rich rhyolite, a volcanic rock. Iron, one of the most common elements on the Earth's surface, can combine easily with oxygen to make minerals with a variety of colors. Rust is an iron oxide, containing both iron and oxygen. The green color that you see when you look at the edge of a sheet of window glass comes from another form of iron oxide. Iron, in combination with other elements, can be red, pink, yellow, gold, green, or black. In general, most of the colors that we see in minerals and gems come from chemical compounds that contain metals such as iron, copper, manganese, and chromium.

Artist's Palette, Death Valley National Park / William Neill

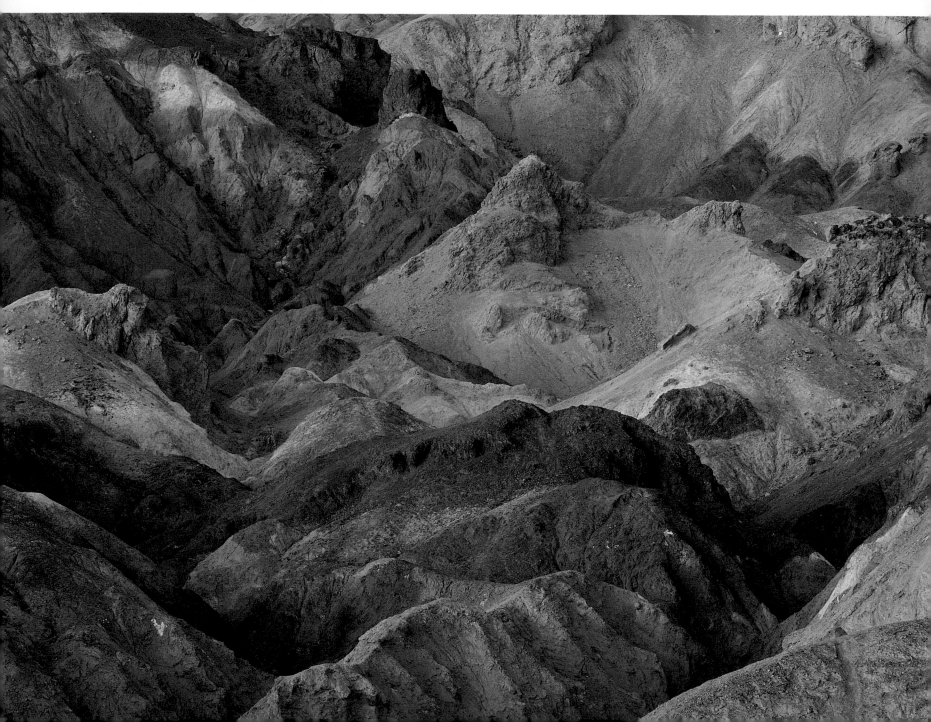

At Bryce Canyon, sediments that collected at the bottom of an ancient inland sea solidified to form minerals that contain pink and yellow forms of iron oxide. When the water evaporated, the rock eroded to form dramatic towers. In this photograph, the yellowish light of the rising sun enhances the yellow tones in the rock formations.

Sunrise Point, Bryce Canyon National Park, Utah / William Neill

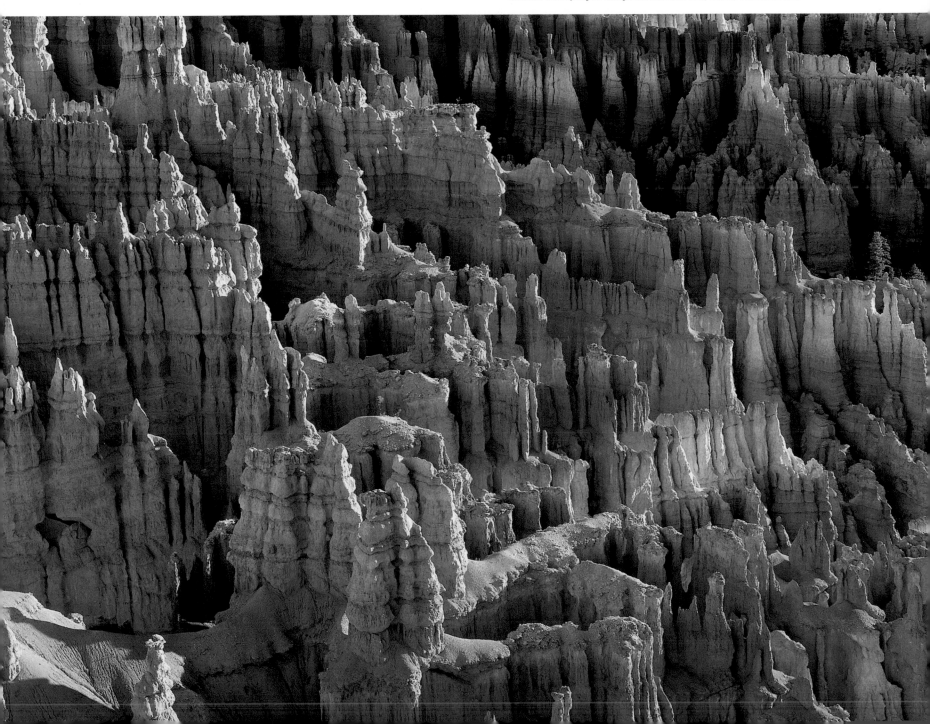

Moon over Sand Dunes, Monument Valley Navajo Tribal Park, Arizona / William Neill

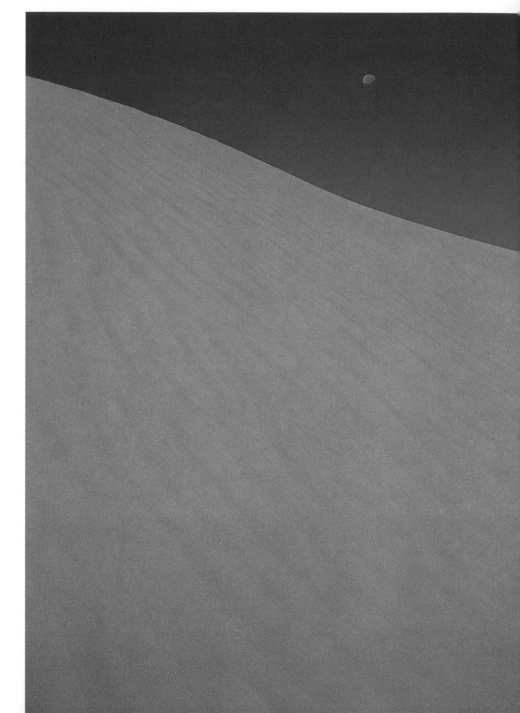

This desert sand is made of quartz crystals that include iron impurities. You can tell the age of a desert by the color of its sand. Sand that was formed relatively recently is yellow in color. If the sand contains iron, which most sand does, the iron atoms oxidize over time, combining with more oxygen atoms. As the iron oxidizes, the color of the sand changes from yellow to red. Red deserts, like those on Mars, are ancient.

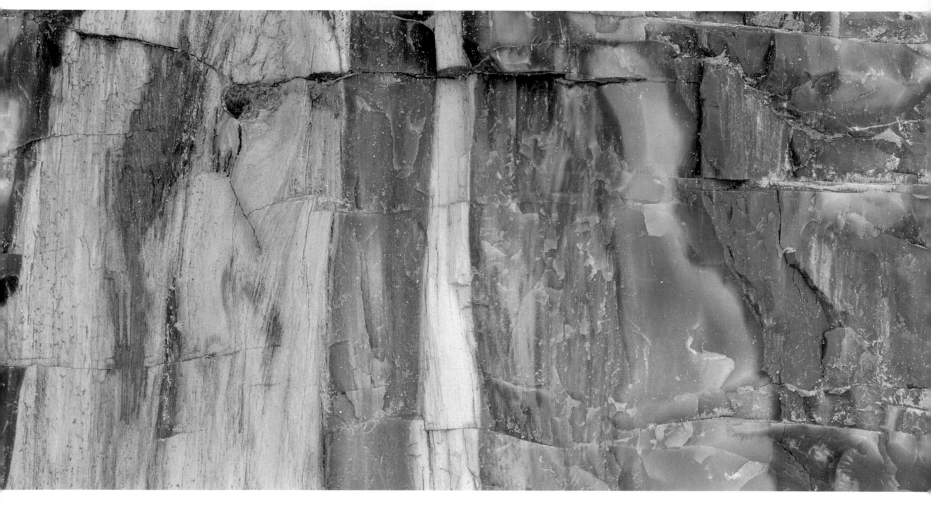

Over time, the wood in this log was replaced with chalcedony and chert, forms of quartz. The colors come from different impurities in the quartz; the structure and patterns in the stone come from the grain of the original wood.

Petrified Log, Petrified Forest National Park, Arizona / William Neill

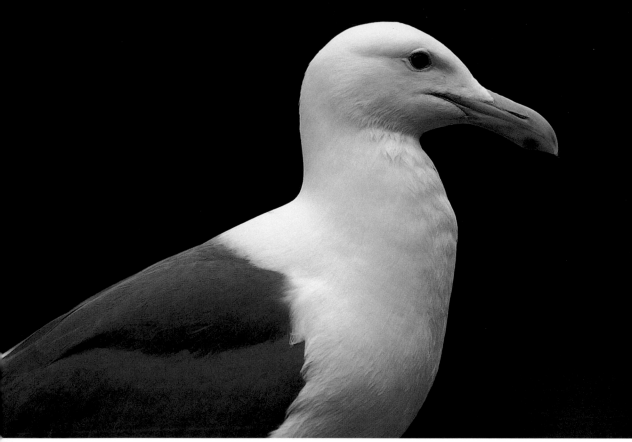

Herring Gull / William Neill

Birds can see in color, but they don't see the same colors that we do.
The color-sensitive cones in the eyes of pigeons and chickens,
the two species of birds whose vision has been studied extensively,
don't respond to blue, indigo, or violet light. These birds can see
best in the green, yellow, and red parts of the spectrum. This increased
sensitivity to greens, yellows, and reds makes a red-and-yellow
pattern, like the red spot on a herring gull's yellow beak, dramatically
visible to a bird. When a gull chick pecks at this red spot on its
parent's bill, the adult gull regurgitates to feed the chick. This stimulus
is so strong that gull chicks will peck at a red spot on anything
that's about the size and shape of their parent's bill.

Gray Flycatcher Feeding Young / Jeffrey Rich

To be fed, these nestlings must open their beaks and display their colorful mouths. The colorful gape stimulates the parents to stuff food into the open mouth. The larger the gaping mouth, the more likely the parent is to reward it with food. When food is scarce, the birds will feed the largest nestlings first. The smaller and weaker birds will die, leaving the parents with a smaller but healthier brood. Parent birds' response to a bright gaping mouth is so strong that they will stuff food into any opening that resembles the mouth of their nestlings. One bird even fed carp that swam near the surface of a pond with their mouths open.

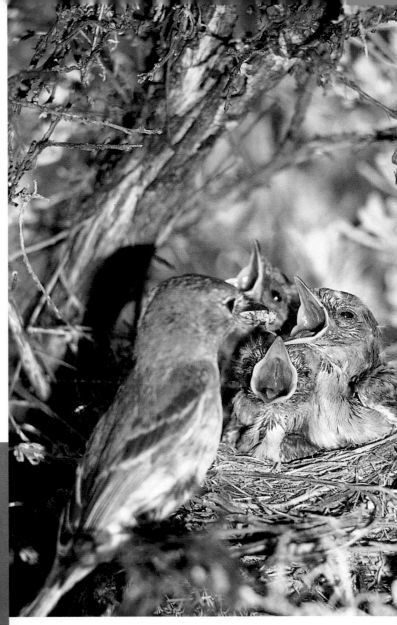

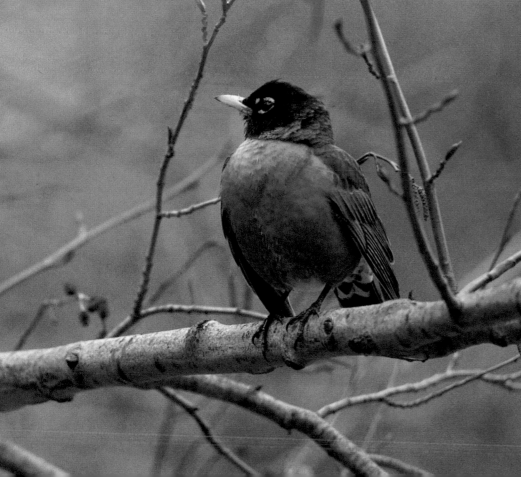

Among animals, patches of color often signal to other animals of the same species. During breeding season, the male robin's red breast notifies other males that this territory is taken. Color signals like the robin's red breast are often matched with specific behavior. An aggressive male robin will turn his red breast toward other males and stretch upward to show the largest possible expanse of red.

American Robin / William Neill

Scarlet Macaws / William Neill

Birds that are cryptically colored to blend in
with their environment rely on other social signals,
such as song. Among birds, the best singers
are usually drably colored. Brilliantly colored species,
like the scarlet macaw, often have unremarkable
songs or no song at all.

Macaw Wing / William Neill

**Grand Prismatic Spring, Aerial View,
Yellowstone National Park, Wyoming** / William Neill

The waters of Grand Prismatic Spring are colored
by primitive photosynthetic organisms known as
cyanophytes, or blue-green algae. Despite the name,
blue-green algae can be green, brown, yellow, black,
or red—as well as blue-green. Different species
of blue-green algae thrive in waters of different
temperatures.

In the center of Grand Prismatic Spring, where the
water is too hot for any algae, the water is deep blue—
the color of water without algae. In the shallower and
cooler waters, each color marks a region of relatively
uniform temperature, where a particular species
of algae thrives.

Glowing colors

2

Distant Stars and Flowing Lava

Candles burn with a flickering yellow light. Flowing lava glows bright red. A bright blue star, like Rigel in the constellation Orion, shines with blue-white light; a red star, like Betelgeuse, also in Orion, is a fiery red.

Glowing Colors:
Distant Stars and Flowing Lava

◀ **Lava Flow Entering the Sea at Twilight from Pu'u O'o Vent, Hawaii Volcanoes National Park, Hawaii** / William Neill

You need light to have color—and sometimes producing light means creating color. But what is light? For centuries, physicists have argued about the answer to that question. Christian Huygens, a seventeenth-century Dutch mathematician, astronomer, and physicist, proposed that light was a succession of waves, like ripples in a still pond. The resulting theory, the wave theory of light, explained many experimental observations. But sometimes light acted in a way that wave theory couldn't explain.

In the early twentieth century, physicists developed quantum theory, which characterizes light as a stream of particles. This theory proposed that the energy of light comes in discrete chunks, or quanta, rather than in continuously varying amounts. Instead of treating light as a wave, quantum theory describes light as a stream of particles called photons.

Today, physicists accept both theories as models for how light behaves. They agree that in different situations light can be characterized either as a series of waves or as a stream of particles, but that neither description alone provides a completely satisfactory explanation of all the things light does.

Whether you think of light as a wave or as a particle, it's always a form of energy. Light shines on a black asphalt driveway, and the driveway gets hot. Light shines on green leaves, and the chlorophyll in the leaves converts light energy into chemical energy in a process known as photosynthesis. Light shines on a solar panel and generates electricity, another form of energy.

Heat is also a form of energy. When something heats up, it gains thermal energy and its atoms vibrate faster and faster. An object that's hot has more fast-moving atoms than a cooler object. In the flame of a candle, in a stream of red-hot lava, or on the surface of the sun, the energy of atomic motion is converted into a different form—the energy of light.

The color of that light reveals the temperature of the object that is glowing. At about 1,300 degrees Fahrenheit (about 700 degrees Celsius), an object produces red light—like the fiery glow from the coil of an electric stove, a stream of cooling lava, or the

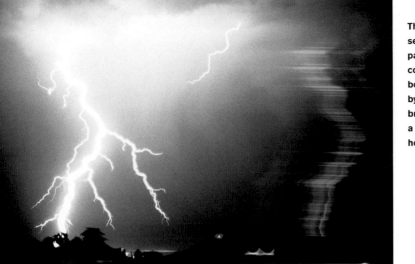

This photograph was taken through a diffraction grating, which separates white light into its composite colors. The resulting pattern of colors reveals that the bright white of the lightning bolt comes from two sources. The bright red, green, and blue lightning bolts are what physicists call a line spectrum, colors produced by excited gases that emit photons at very specific energies. The bright horizontal bands that join the colored lightning bolts are a continuous spectrum, colors produced by gases heated to white-hot by the lightning bolt.

Flames of a Campfire / William Neill

surface of a red dwarf star. At about 2,700 degrees Fahrenheit (about 1,500 degrees Celsius)—the temperature of the particles of burning soot in the flame of a candle—the light produced is orange-yellow. At about 10,300 degrees Fahrenheit (about 5,700 degrees Celsius)—the temperature of the surface of the sun or the spark of a carbon-arc lamp—the light is white. And if the temperature is over 36,000 degrees Fahrenheit (20,000 degrees Celsius), as it is at the surface of a type of star known as a blue giant, the light is bluish white.

Why does light change color with temperature? Imagine a stream of red-hot lava. The atoms in that hot lava are vibrating fast. These rapidly vibrating atoms give up some of their energy by spitting out photons, or particles of light. The energy of each photon exactly matches the energy that the lava has given up.

According to quantum theory, the energy of the released photons determines the light's color, and the number of released photons determines the light's intensity. Pure red light is made up of low-energy photons. Pure blue light is made up of photons with more energy.

Red-hot lava is barely hot enough to emit any photons, so most of the photons that the lava atoms give up are low-energy photons. A candle flame is hotter than lava and therefore has more thermal energy per atom. The flame has some atoms that are moving slowly—but it also has some that are vibrating very fast. The candle flame spits out not only low-energy photons of red light, but also many more of the higher energy photons that make up yellow light. Something that's hotter still, like the surface of the sun, emits photons with a range of energies, producing all the colors of visible light. The combination of all these colors makes white, the color of sunlight. And something that's still hotter than the surface of the sun, like the surface of a blue giant, produces even more high-energy photons, glowing bluer than the sun.

Light that is produced by something being heated is called incandescence. In incandescence, thermal energy is converted to light. But if you've ever touched a glowing neon sign, you know that it stays cool. Heating something up isn't the only way to make light.

The flames of a campfire glow with incandescent light, produced when the energy of atomic motion is converted into the energy of light. The color of incandescent light reveals the temperature of the glowing object. The coals of a fire begin to glow red at 1,300 degrees Fahrenheit (about 700 degrees Celsius). The flames, in which particles of soot are burning, are orange-yellow, which indicates a temperature of at least 2,700 degrees Fahrenheit (about 1,500 degrees Celsius). The flashes of green in this campfire come from salts that were sprinkled in the flames. The heat of the fire vaporizes the salts, and the resulting gas glows with a color characteristic of that particular salt.

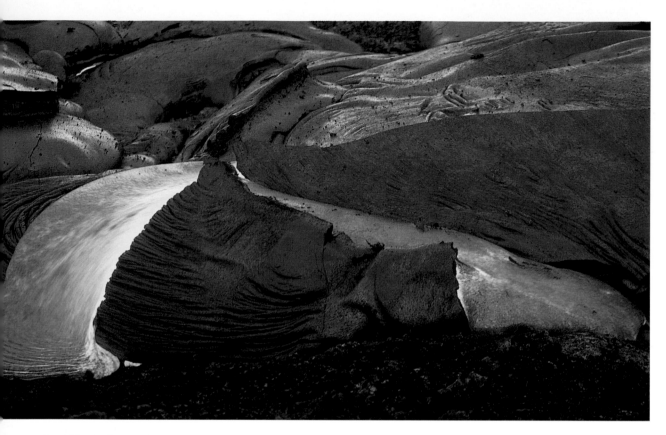

The colors of this flowing lava reveal its temperature. As the lava cools, it emits photons with lower energies, indications of a lower temperature. The band of bright yellow lava is hotter than the red lava that surrounds it. The photons in red light have less energy than those in yellow light. The black lava is emitting photons of infrared radiation, which have even less energy than the photons of red light. Your eyes can't detect infrared, but if you were to hold your hand near the black lava you could feel the heat carried by this radiation.

Lava Flowing from a Vent, Hawaii Volcanoes National Park, Hawaii / William Neill

In a neon tube, electrical energy is converted to light as an electric current flows through a gas-filled tube. Modern neon signs use many kinds of gases, but suppose the tube that we're talking about is filled with neon gas. The moving electrons that make up the electric current collide with atoms of neon gas, and the atoms absorb some of the electrons' energy. A physicist would say that the atoms were excited by the electrical current. These excited neon atoms emit energy in the form of light, and the neon sign glows red, a color characteristic of neon gas.

Different gases, excited by an electric current, glow with different characteristic colors. Glowing sodium gas, for example, produces bright yellow light, and glowing mercury vapor produces blue-white. According to quantum theory, that's because each gas emits energy only in specific quantities, producing photons of specific energies.

An atom absorbs energy and becomes excited when its electrons move to what physicists call a higher energy state. An atom emits light when those electrons return to a lower energy state. One way to understand why atoms can only absorb and emit certain quantities of energy is to compare an atom's electrons to rubber balls on a staircase. You can kick a ball upstairs or roll it downstairs, but the ball will always end up on one step or another, never in between.

Like the ball, an electron can occupy only certain positions or energy states. Just as the ball bouncing downstairs loses energy in certain predetermined amounts, an electron dropping from a high or excited energy state to a lower energy state can lose only certain amounts of energy. The electron releases this energy in the form of a photon of light, a particle that has a specific energy and therefore a specific color.

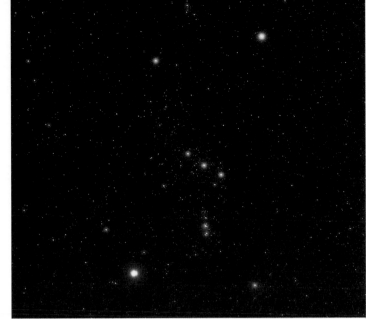

Constellation of Orion / Johnny Horne

The constellation of Orion, the Hunter, is a good place to look to see stars of different colors. A star's color corresponds to its surface temperature. The star that forms Orion's right shoulder is Betelgeuse, a red supergiant star with a surface temperature of about 5,400 degrees Fahrenheit (about 3,000 degrees Celsius). The star that forms Orion's left foot is Rigel, a blue supergiant with a surface temperature of over 54,000 degrees Fahrenheit (about 30,000 degrees Celsius). The central bright point of Orion's dagger is the Orion Nebula, a giant gas cloud illuminated by a star.

Atoms of different gases have different atomic structures. Therefore they have different internal staircases—they gain and lose energy in different amounts and produce light of different colors.

In creating neon signs, humans have duplicated the method, if not the splendor, of nature's most dramatic displays of colored light: the aurora borealis and the aurora australis, also known as the northern lights and the southern lights. When conditions are right, the solar wind, a stream of electrons and protons flowing from the sun, interacts with the Earth's magnetic field to create electric currents in the atmosphere near the poles. These currents excite atmospheric gases, producing a brilliant light show.

Light that is produced by excited gases—whether those gases are in a neon tube or in the Earth's atmosphere—can appear to be a color similar to that of the incandescent light produced by something hot. Your eyes don't distinguish between the two, but if you shine these colored lights through a diffraction grating or a prism to separate them into their component colors, you see a dramatic difference.

Incandescent light shining through a prism creates what you might call a rainbow and a physicist might call a continuous spectrum—brightly colored bands that merge. Light from excited gases, on the other hand, creates a series of distinct bright lines, which a physicist would call a line spectrum. The pattern of these lines depends on the composition of the excited gas.

No matter what sort of spectrum a light source produces, whenever you see something producing light, you know that energy is being converted from one form to another. In a glowing candle flame, thermal energy becomes light. In the cells of a firefly's body, chemical energy is converted to light. In the glowing displays of the northern lights and in neon signs, electrical energy is converted to light. In these situations and others, the color of the light always depends on the quantity of the energy that is being converted by each atom in the glowing object.

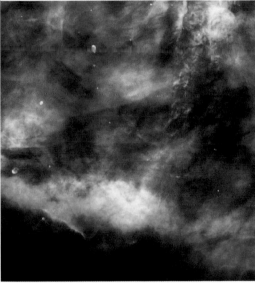

Orion Nebula / NASA

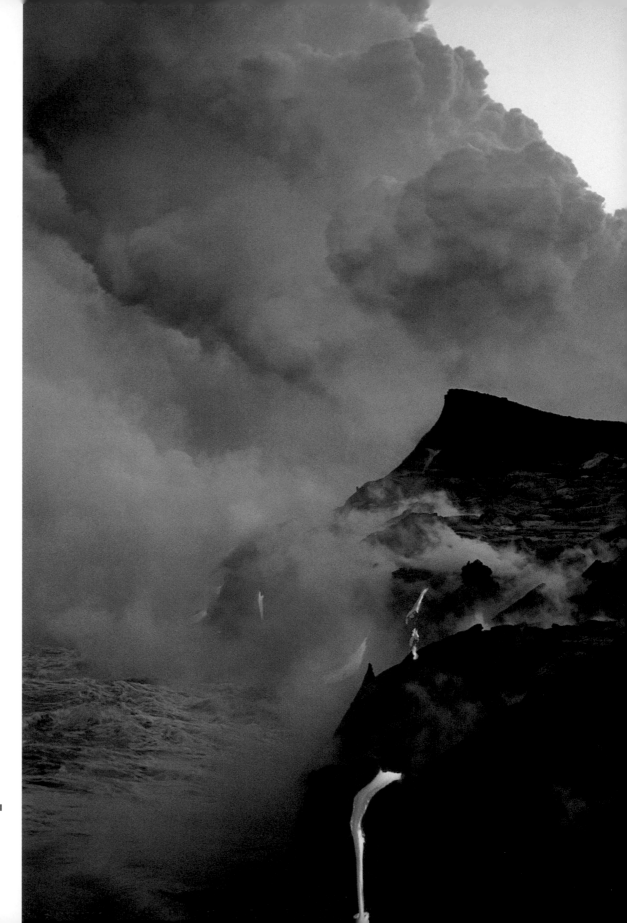

On Hawaii's Kamoamoa coast, lava flows into the sea, sending up clouds of billowing steam. The flowing lava glows with incandescent light. The color of the light indicates the temperature of the molten rock, with bright yellow lava being hotter than red.

Lava Flow Entering the Sea at Twilight from Pu'u O'o Vent, Hawaii Volcanoes National Park, Hawaii / William Neill

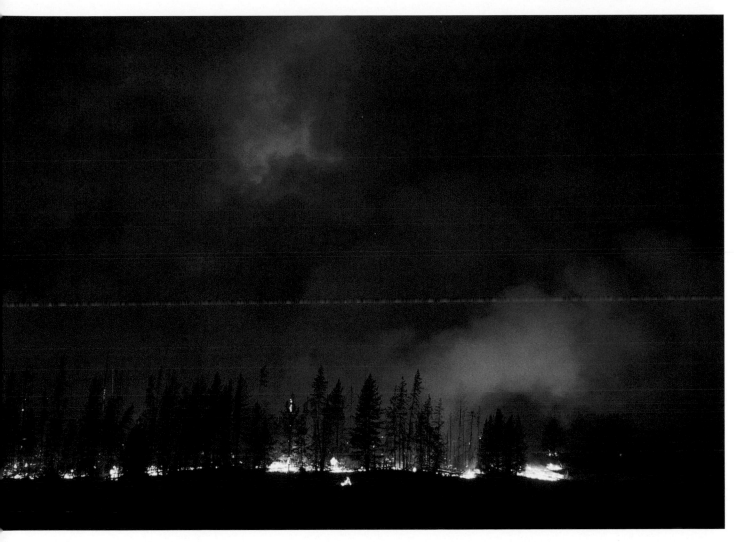

The glow of a forest fire illuminates billowing smoke with crimson light.
Bright yellow patches on the ground indicate spots where the fire
is still burning hot.

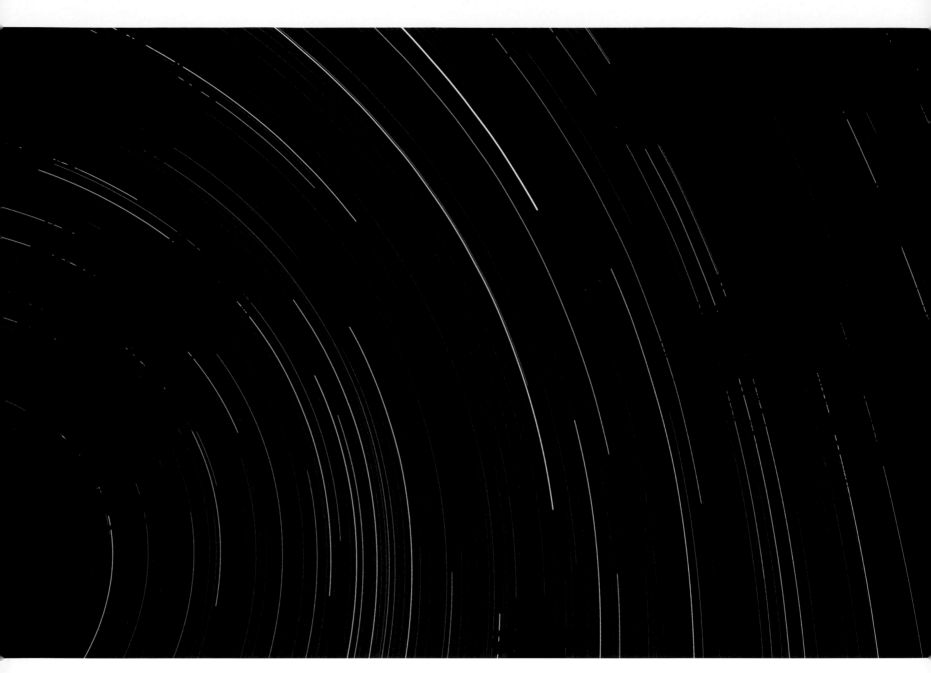

Star Trails above Crater Lake, Oregon / William Neill

This photograph, taken with a six-hour exposure, **reveals the colors of the stars.**

As the Earth turns, the stars appear to move across the sky. The center of these concentric arcs of stars is Polaris, or the North Star, the only star that remains relatively stationary in the sky of the northern hemisphere.

Cygnus Loop / Jeff Hester

This photograph, taken through the Hubble Space Telescope, shows a portion of a nebula called the Cygnus Loop. About 15,000 years ago, a supernova exploded and sent a shock wave into a cloud of denser-than-average interstellar gas, which caused the gas to glow. The colors produced indicate the composition of the glowing gases: blue comes from oxygen atoms, red from sulfur atoms, and green from hydrogen atoms. This supernova remnant lies 2,500 light-years away from Earth, in the constellation Cygnus, the Swan.

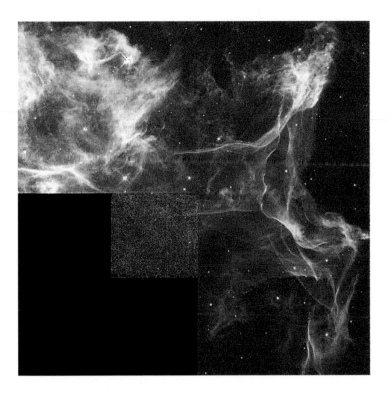

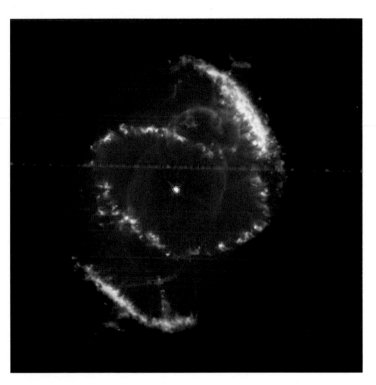

Cat's Eye Nebula / J. P. Harrington and K. J. Borkowski

This photograph, taken through the Hubble Space Telescope, shows the Cat's Eye Nebula, more formally known as NGC 6543. To an astronomer, the shapes and structures of this nebula's glowing gases provide a record of the dynamics of a dying star. Astronomers speculate that the Cat's Eye Nebula may surround a double-star system. The two stars are close together and appear as a single point of light at the center of the nebula. This color photograph is a composite of three color images: one taken using red light, one using blue light, and one using green light.

The aurora australis

was photographed from the flight deck of the space shuttle *Discovery* in the spring of 1991. From space, the aurora australis and aurora borealis appear as rings of glowing gas, each about 2,500 miles in diameter, hovering over the North Pole and the South Pole. These luminous rings form when the solar wind, a stream of charged particles flowing from the sun, collides with the Earth's magnetic field and generates electric currents. In the Earth's atmosphere, these currents excite gas atoms and molecules, which give off colored light.

Aurora Australis, or Southern Lights / NASA

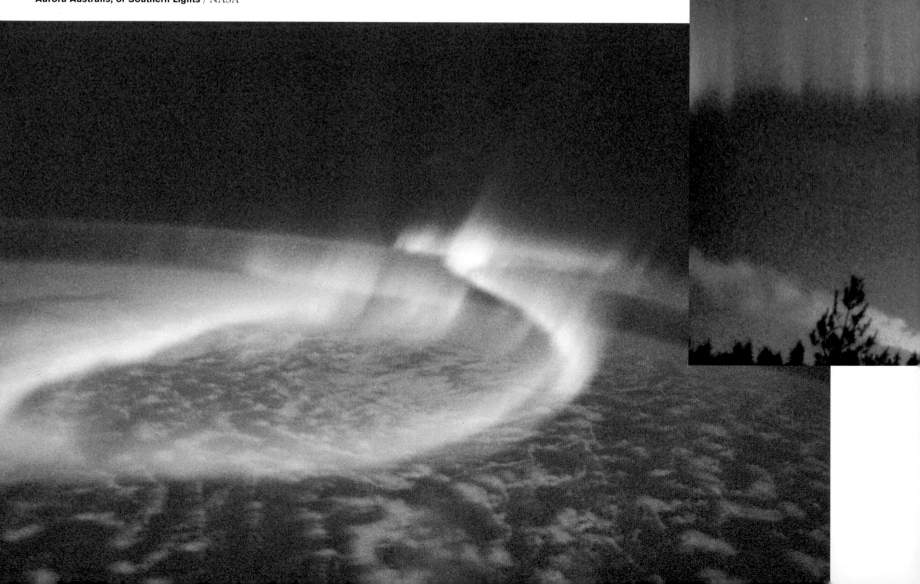

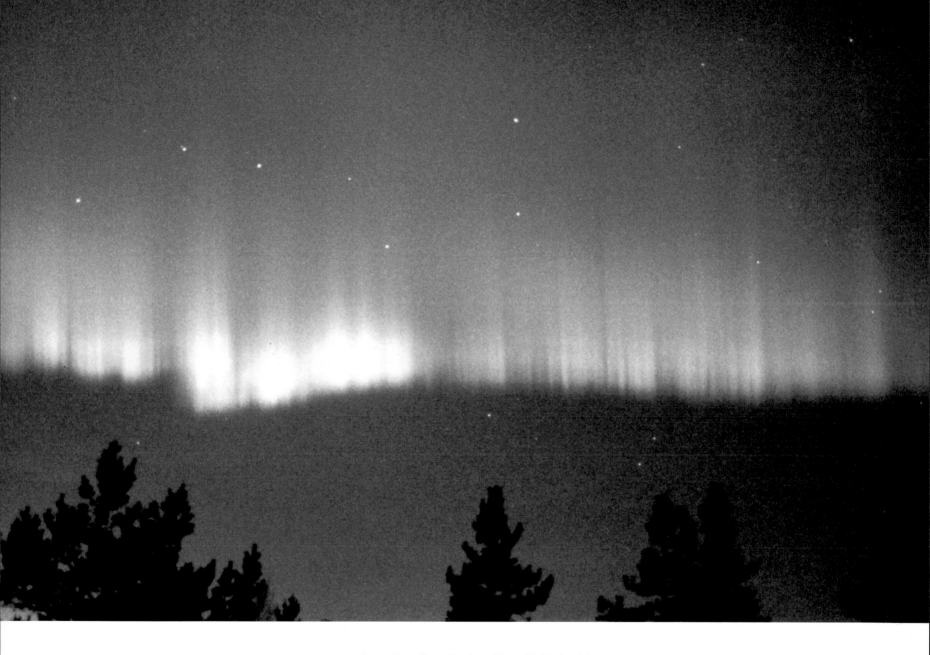

Aurora Borealis, or Northern Lights / Pekka Parviainen

This undulating curtain of green light is the aurora borealis, viewed from Finland. The top margin of the auroral curtain may be 250 to 600 miles above the Earth's surface, and its lower edge may extend to within 60 miles of the surface. Its green color comes from oxygen gas that has been excited by electrical currents generated by the solar wind.

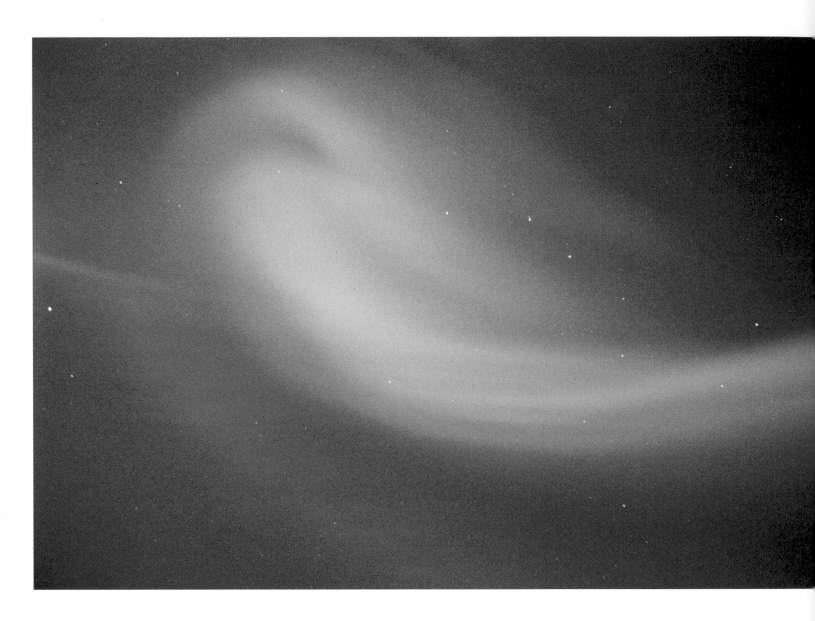

Aurora Borealis, or Northern Lights / Pekka Parviainen

The eddies and swirls in the aurora reveal the eddies and swirls in the
electric currents that are created as the solar wind interacts with the
Earth's magnetic field. Auroras ripple and flicker as these currents shift
and move. Notice that the stars of the Big Dipper are visible through the
blue glow of the aurora.

Barrow, Alaska, the aurora borealis is visible just about every cloudless night during autumn, winter, and spring. (In summer, the aurora is still there, but round-the-clock sunshine renders its subtler light invisible.)

Sometimes the aurora dips closer to the equator, but your chances of seeing an auroral display diminish as you get farther from the poles. Some years are better for seeing auroras than others. The next peak of auroral activity is expected in or around the year 2002.

This photograph, taken with a wide-angle lens of the sky overhead, shows a dramatic starburst of red and blue rays. Many cultures have myths that explain the dramatic and changing colors of the aurora. The Finns told of magical "fire foxes" whose fur gave off bright sparks that lit up the sky. The people of the Hebrides Islands off the coast of Scotland attributed the lights to a tribe of shining fairies called the "nimble men." Scandinavian myths told of the spirits of unmarried women who created the lights when going about their spiritual business: making fires, cooking fish, dancing, and waving their white-gloved hands. Other cultures have less benign interpretations of the lights: the Kurnai of southeastern Australia regarded them as a terrible warning and a sign of the wrath of the Great Man, Mungan Ngour.

Aurora Borealis, or Northern Lights / Pekka Parviainen

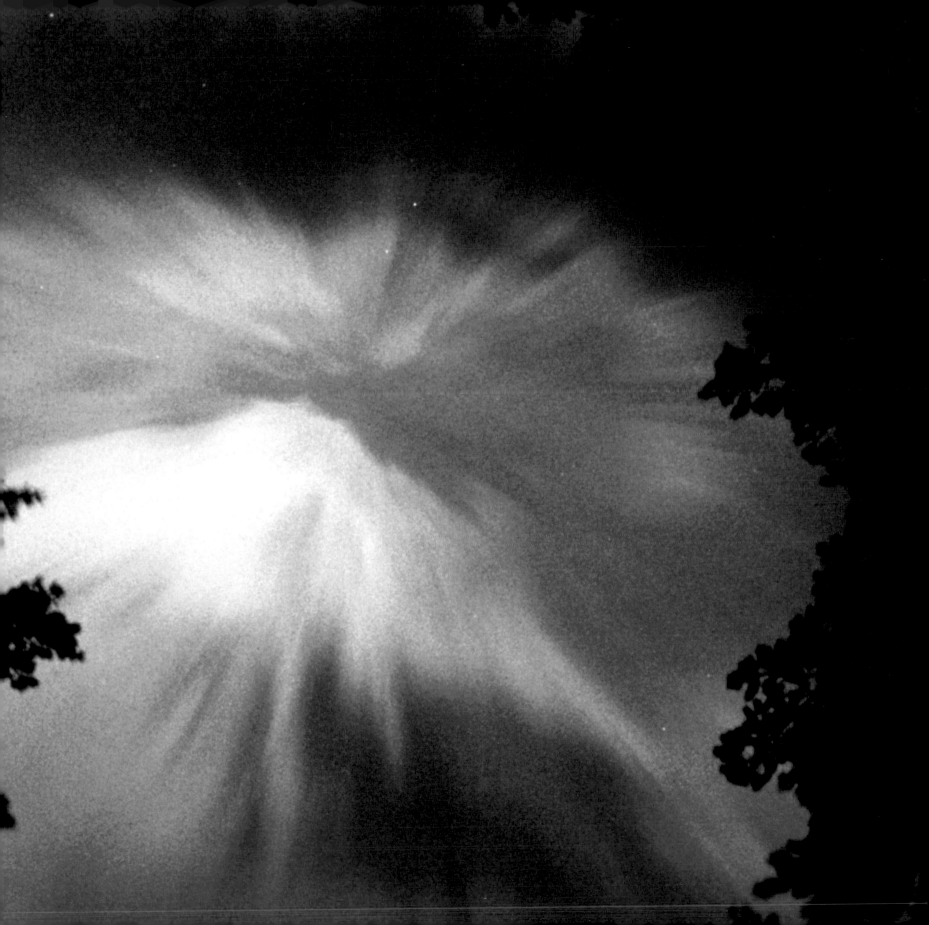

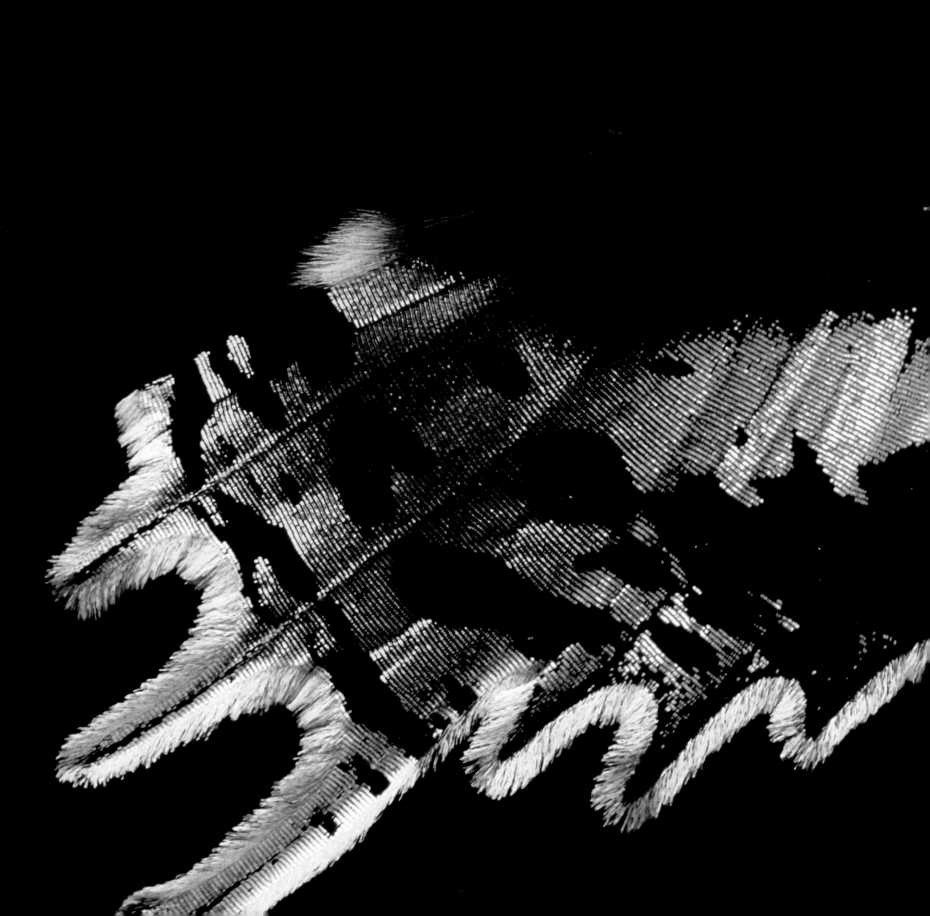

Shimmering

colors

3

Bubbles
and Butterfly
Wings

Think about the last time you saw a soap bubble— floating on a summer breeze or caught in the foam of a sink full of dishes.

What color was it?

Shimmering Colors: Bubbles and Butterfly Wings

That's a hard question to answer. In one light, a soap bubble may appear clear and colorless. Put a dark background behind it, and suddenly the bubble will be awash with shifting hues. A puff of wind sends the colors swirling in eddies of black, silver, yellow, magenta, blue, and green.

The soap bubble—like an oil slick on a city street, the feathers on the neck of a mallard drake, and the wings of certain tropical butterflies—owes its shimmering colors to reflecting light. In all these situations, light beams reflecting from different surfaces combine to create iridescent colors that shift and change. To understand what produces these beautiful colors, you need to know something about the nature of light and something about the nature of waves.

To most people, a wave is a moving ripple in the water, lapping at the feet of a beachcomber or rocking a fisherman's boat. To a physicist, a wave is a traveling disturbance. Toss a stone in a pond, and ripples from the splash will lap against the shore. Pound on a drum, and sound waves will travel through the air to start your eardrums vibrating. Waves transmit motion, pushing and pulling on things in their path so that a disturbance in one place and time causes a disturbance in another place and time.

Since waves are traveling vibrations, rather than physical objects, two waves can be in the same place at the same time. Suppose two ocean waves of equal size meet. Each wave is pushing up and down on the water in its path. Where the waves meet, there are two different forces acting on the water, one from each wave. If both waves are pushing up on the water, the water moves twice as high as it would move if it were pushed by one wave alone. If one wave is pushing up and the other is pushing down, the two pushes cancel each other and the water doesn't move at all. These waves are said to interfere with each other.

What does all this have to do with light and color? One way to understand light is to think of it as being made up of waves. Physicists often talk about light waves in explaining some of the things that light does.

Light waves begin with the vibration of electrons—the negatively-charged particles that orbit the nucleus of an atom. Vibrating electrons in the

To your naked eye, white light shining through these crystals would look white. To reveal these interference colors, the crystals were illuminated with polarized white light and photographed by a camera equipped with a polarizing filter.

Vitamin B-1 / Dennis Kunkel

When two waves meet, they can add together or cancel each other in a process known as interference. If the crests of the waves match up, they add together, a process called constructive interference. If the crest of one wave meets the valley of another, the two waves cancel, a process known as destructive interference. When light waves of a certain color add together, that color becomes brighter. When they cancel, that color disappears.

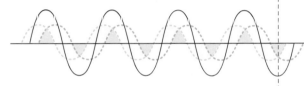

WAVES ADDING TOGETHER
(Constructive Interference)

WAVES CANCELLING
(Destructive Interference)

atmosphere of the sun send out light waves in all directions. Some of these light waves, traveling at 186,000 miles per second, cross the 93 million miles from the sun to the Earth, reaching the surface of the planet eight minutes later. When this sunlight gets into your eyes, the light waves make electrons at the back of your eyes vibrate, echoing the original vibration of electrons on the sun.

One way to measure a wave—whether it's a light wave in sunshine or a water wave on the ocean—is to look at it as if time were standing still. The distance between the crests of the wave gives you a measurement known as wavelength.

Sunlight is made up of light waves of many different wavelengths. Each wavelength is light of a different color. Violet light has the shortest wavelength of all the colors you can see, measuring about 400 nanometers from crest to crest. A nanometer is a metric unit that's equal to one-billionth of a meter. To give you an idea of how small this is, 100 nanometers is a thousand times thinner than a human hair.

Red light has the longest wavelength of all the colors of visible light, measuring about 700 nanometers. The other colors of the rainbow have wavelengths between red and violet. Sunlight also includes light waves that have longer wavelengths than violet light (ultraviolet) and shorter wavelengths than red light (infrared), but your eyes can't detect these frequencies.

When sunlight reflects from very thin layers of material, the reflecting light waves meet and interfere with each other. Some of the light waves add together to make brighter light of certain colors. Some of the waves cancel out, removing one color from the mixture. Since white light is made up of a blend of all colors, subtracting one color and making other colors brighter changes the light from white sunlight to the colors that you see on a soap bubble or a blue morpho butterfly's wing.

Soap Film Painting, Exploratorium,
San Francisco, California / Susan Schwartzenberg

For the reflecting light to interfere, the distance between the reflecting layers must be very small—so small that they are less than a few wavelengths of light apart. The size of this gap is what determines which wavelengths of light add together and which ones cancel.

That's why wind makes the colors of a soap bubble shift and swirl. A bubble is a puff of air enclosed in a thin soap film. This soap film is a sort of sandwich: a layer of soap molecules, a filling of water molecules, and then another layer of soap molecules. You see colors in a soap film when light waves reflecting from one layer of soap molecules interfere with light waves reflecting from the second layer of soap molecules. The interference colors depend on how far the light waves have to travel before they meet up again—and that depends on the distance between the layers or the thickness of the soap film. By causing the liquid bubble film to flow and change in thickness, a puff of wind makes the bubble colors swirl and change.

Iridescent colors also change when you change the angle from which you are viewing the iridescent surface. Viewed from above, the wing of a morpho butterfly is a brilliant blue. If you tilt the wing, the color shifts from blue to blue-green, then to a dull reddish-purple.

The scales on the butterfly's wing have layers of chitin, a horny material also found in the shells of beetles and the external skeletons of many insects. The brilliant colors of the butterfly's wing are reflecting from these layers of chitin. When you're looking directly down on the wing, the light that reaches your eyes has bounced off these layers at a 90-degree angle, taking the shortest path through the microscopic gaps between the layers. When you tilt the wing, you are seeing light that bounces off the scales at an oblique angle, taking a longer path across the gaps. By changing the angle, you are changing the distance that the light has to travel between the layers of scales, and that changes the color.

SOAP FILM

When you dip a bubble wand in a soap solution, a soap film forms on the hoop. If you turn the wand so that the soap film is perpendicular to the ground, you may see stripes of color in the film. Viewed against a dark background, the topmost part of the film will be black. As you move from the top of the hoop, the stripes will be yellow-white, then magenta, then blue-green. As you continue downward, the sequence will repeat. Each colored stripe corresponds to a different thickness of the soap film.

These are interference colors, created when light reflecting from the front surface of the film meets light reflecting from the back surface of the film. Light waves reflecting from the back surface must travel through the film, bounce off the back surface, then travel through the film again before leaving the film and meeting the light waves reflecting from the front surface.

When the film's thickness is exactly one-quarter of a wavelength of light, light waves of that color meet so that the crest of one wave matches up with the crest of another wave. The waves add together and get brighter, a process known as constructive interference. When the thickness of the soap film is equal to half a wavelength, the light waves meet so that the crest of one wave matches up with the trough of the other wave. These waves cancel, subtracting that light from the mixture, a process called destructive interference. Since each color of light has a different wavelength, some colors get brighter and others cancel when the film's thickness changes.

When the soap film is at its thinnest, all the reflecting wavelengths of light cancel, leaving a soap film that looks black. When the soap film is black, it's less than one-millionth of an inch thick, and it's just about to pop.

The mother-of-pearl coating

that lines the inside of an abalone shell is made up of alternating layers of calcium carbonate and water. Light waves reflecting from these layers interfere with each other, producing iridescent colors. Pearls themselves, like this mother-of-pearl, owe their lustrous beauty to alternating layers of calcium carbonate and water. If a pearl becomes so dry and hot that all the water evaporates, it will turn dead white and lose its iridescent quality. That's why jewelers recommend wearing pearls next to the skin, which is moist.

This photograph, taken through a scanning electron microscope, shows the submicroscopic layers of calcium carbonate that give the abalone shell its iridescent colors. It takes about a thousand of these layers to add up to the thickness of a human hair.

Layers in Abalone Shell / W.G. May

Abalone Shell / William Neill

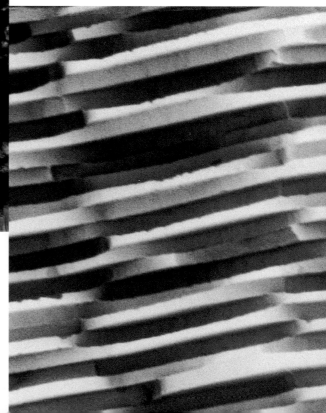

An oil slick floating on water has two reflective surfaces—the surface where the air meets the oil and the surface where the oil meets the water. When light waves reflecting from these two surfaces meet, they combine to make beautiful colors. Like the colors of a soap film, these interference colors reveal how far apart the two reflective surfaces are—in this case,

the thickness of the layer of oil.

Even the best photograph of the sunset moth can't do justice to its brilliant irides-
cent colors. A photograph can capture only a single view of these brilliant colors;
the colors of the actual wing shift as you change your angle relative to the wing.
These colors are produced by light reflecting from submicroscopic structures in
the scales that cover the moth's wings. The sunset moth, which is native to
Madagascar, is part of the Urania family. Though classified as a moth, this insect
is as brilliantly colored as any butterfly and generally is active in the daytime.

Sunset Moth Wing / William Neill

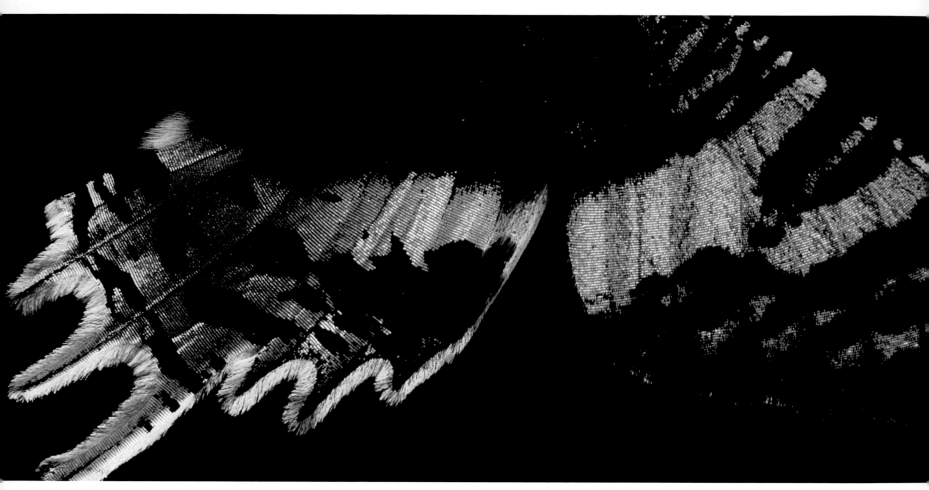

This photograph, taken through a micro-
scope, shows the rows of transparent,
overlapping scales that give the blue mor-
pho butterfly's wing its vibrant color. Each
scale is less than four hundredths of an
inch across. Within each tiny scale are lay-
ers of chitin, a horny material that makes
up the external skeletons of insects.

These layers of chitin are 110 nanometers
apart, about a thousand times thinner than
a human hair. The scales reflect blue light
when viewed from above because 110
nanometers is equal to one-quarter of a
wavelength of blue light.

Scales on a Morpho Butterfly Wing / Heather Angel

Blue Morpho Butterfly / William Neill

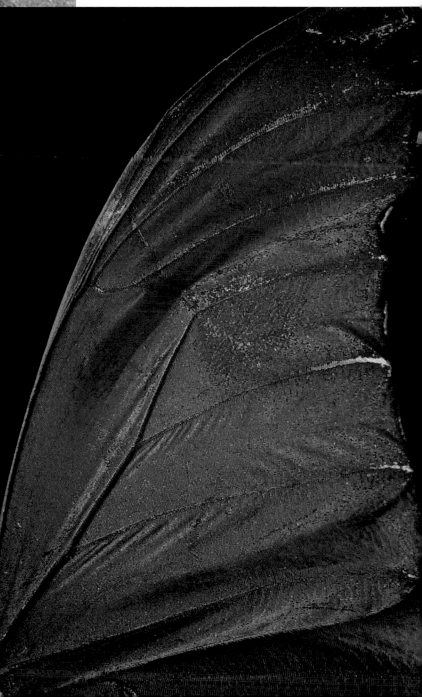

The morpho butterflies, which belong to

a family native to Central and South America, have been eagerly sought by collectors and jewelry makers for their opalescent blue wings. Even the smaller morpho species have wingspreads of 4 inches; larger ones may be 6 inches across. In flight, the wings of these butterflies are so bright that naturalists have reported seeing flashes of blue from a quarter of a mile away. Surprisingly, there is no blue pigment in the morpho's wings. Microscopic studies have revealed that the wing is covered with tightly packed rows of scales that overlap like shingles on a roof. Light reflecting from these scales creates brilliant shades of blue. The underside of a morpho's wing is a dull brown, the color of the pigment that underlies the butterfly's reflective scales.

Like the soap film and the oil slick, the wing of a damselfly is a thin film. Light waves reflecting from the front surface of the film meet and interfere with light waves reflecting from the back surface of the film to produce iridescent colors.

Black-Winged Damselfly / Joe McDonald

Most people don't think of beetles as beautiful, but some tropical jewel beetles have striking iridescent colors. In many parts of the world, the carapaces, or shells, of these metallic-looking insects have been used in ornaments and ceremonial clothing. Like the colors of the soap bubble and the oil slick, these iridescent colors are created by the interference of reflected light waves.

Jewel Beetle / William Neill

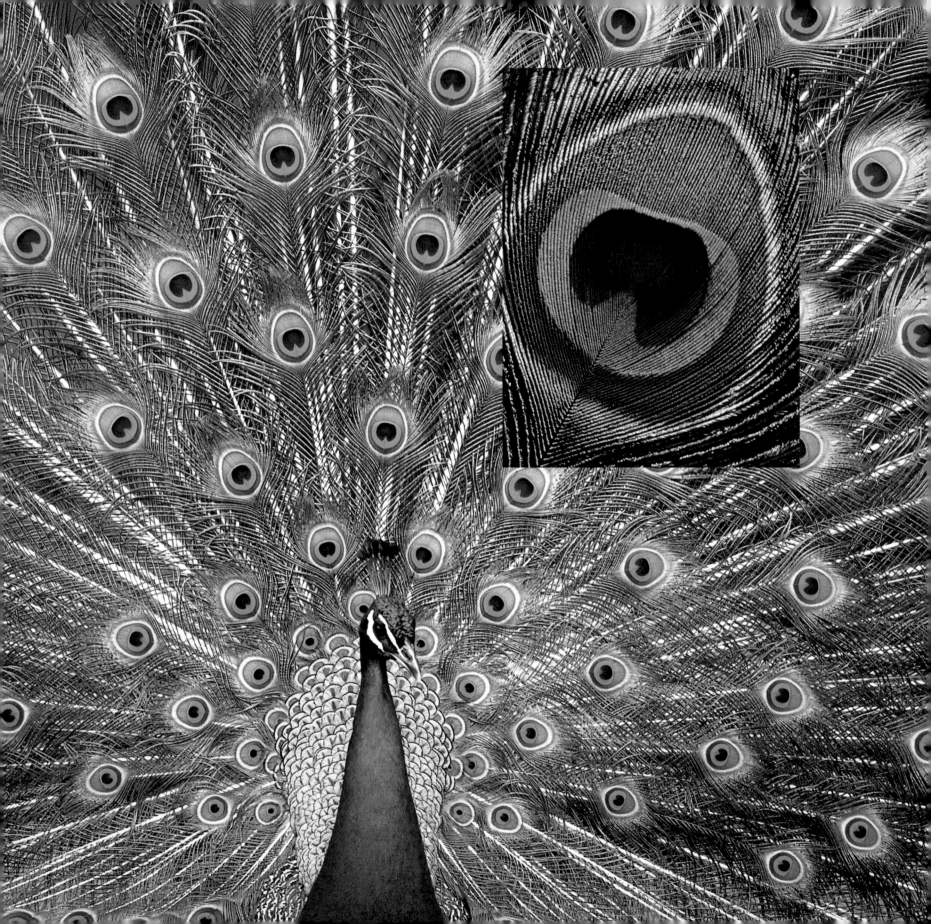

On most hummingbird species, patches of iridescent feathers cover small areas of the bird's head and a region of the throat called the gorget. These colors are visible only from up close—and then only from the right position. From one angle, the bird's feathers are a brilliant magenta; from another angle, the same bird looks dull and dark. Within the iridescent feathers, a microscope reveals thin layers of pigment separated by air-filled gaps. These submicroscopic structures reflect colors strongly from certain angles.

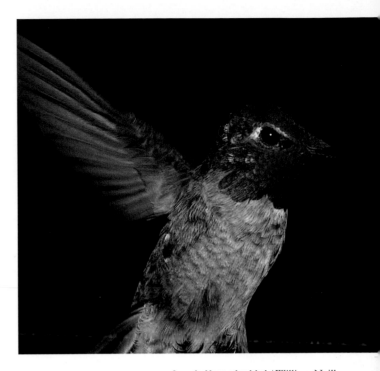

Anna's Hummingbird / William Neill

The male peafowl, or peacock, displays his tail to attract the attention of a mate.

The brilliance of his tail is important to his success in mating. Studies have suggested that the peahen bases her judgment of the peacock's suitability as a mate on his colorful display.

Isaac Newton mentioned the peacock in his 1704 *Treatise on Optics,* having noticed that moving the bird's tail feathers caused the colors to shift subtly. The blue-green in the eye of the tail feather reflects from a regular array of pigment-filled rods. These structures are submicroscopic, with about 18,000 pigment rods packed into just one-eighth of an inch. In other areas of the feather, the rods in the array are separated by different distances. The color that reflects from each part of the feather depends on the spacing and layering of the rods and on the angle at which light reflects from the feather.

Peacock Displaying,
Peacock Tail Feather / William Neill

Resplendent Quetzal Feather / Frans Lanting

The quetzal of Central and South America is noted for its shimmering feathers; its name comes from the Nahuatl Indian word for "tail feathers." But you don't have to go to an exotic location to find iridescent birds. A close look at the European starling, a bird native to Europe and introduced to North America, reveals patches of iridescence. You can also see iridescent feathers on pigeons, doves, mallard drakes, wild turkeys, and pheasants.

European Starling Wing Feather / Frans Lanting

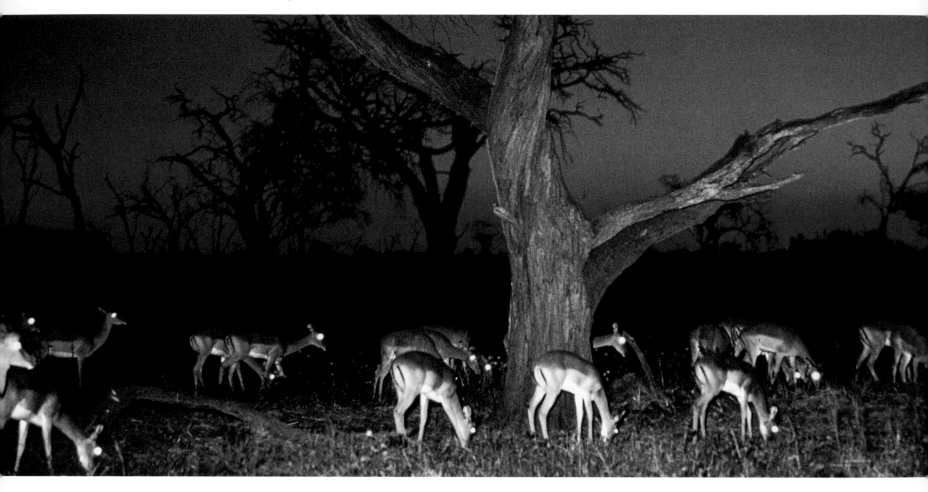

You've probably noticed that the eyes of certain animals gleam when they are caught in the headlights of your car. Back behind the light-sensitive cells in the eyes of these animals are layers of reflective tissue that bounce the light back out through the pupils. The reflecting light interferes to give this eyeshine a characteristic color.

Animals that have this reflective tissue in their eyes usually have good night vision. The eyes of such animals have two chances to detect light—once when it enters the eye and again when it reflects back out. This makes the animal's eyes more sensitive to light—but results in an image that's a little blurry. Though the animal can see in dim light, it lacks the ability to see fine detail.

Your eyes don't glow like a cat's. Behind the photosensitive cells inside your eye is a layer of dark pigment that absorbs light. When light shines into your eyes, very little of it reflects out.

Iron Pyrite / William Neill

This stone is a pyrite sun, a naturally occurring form of iron pyrite. A very thin layer of iron oxide on the stone's surface reflects light to your eyes. This light interferes with light reflecting from the underlying iron pyrite to produce shimmering colors.

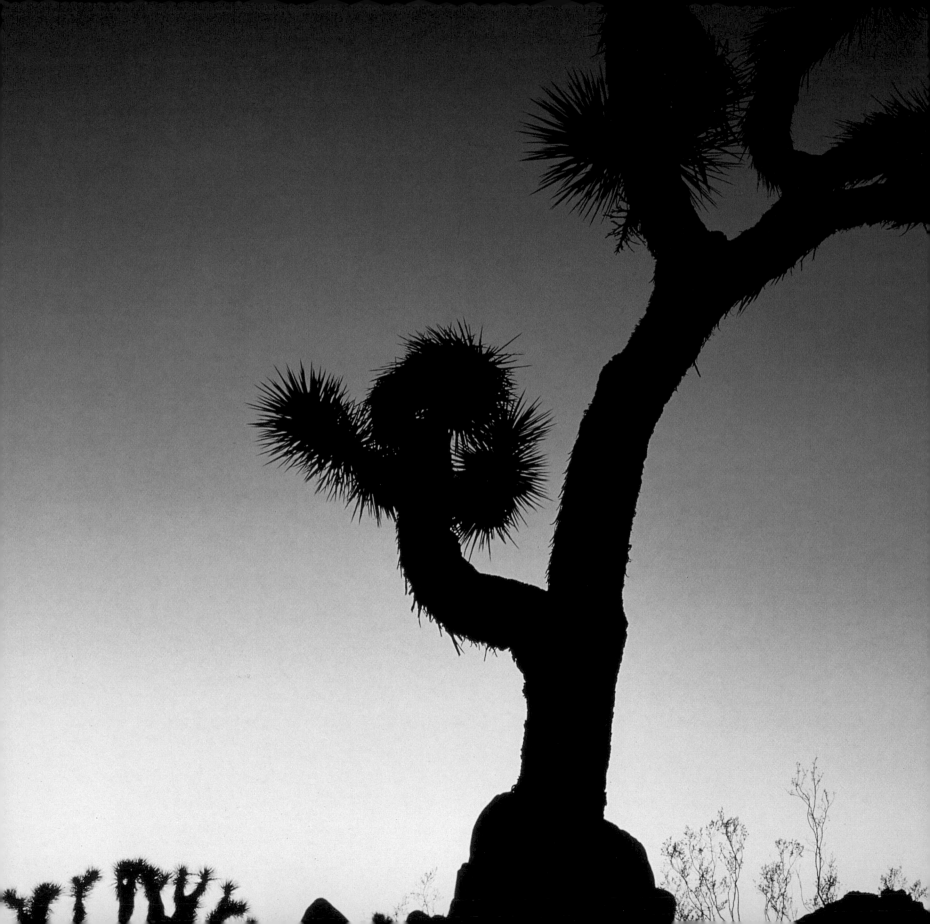

Scattered

4

colors

Crimson
Sunsets and
Blue-Tailed
Geckos

Paul Newman's eyes, the feathers of a blue jay, and the tail of a blue-tailed day gecko are all shades of blue. But none of these things contain blue pigment.

Scattered Colors:
Crimson Sunsets and Blue-Tailed Geckos

◀ **Joshua Tree and Moon at Dawn,**
Joshua Tree National Park,
California / William Neill

They owe their color to the same phenomenon that paints the desert sky a deep pure blue, gives distant mountains a blue tone, and tints sunsets a fiery crimson. In all these situations, tiny particles interact with white light to make color.

The particles that color the desert sky are the atoms and molecules that make up Earth's atmosphere. When sunlight shines down through the Earth's atmosphere, some of it hits air molecules and bounces away from them in all directions, a process known as Rayleigh scattering. In sunshine, all of the colors of the rainbow combine to make light that we see as white. If air molecules scattered these colors equally, the sky would be as white as a snowbank or the water droplets of a cloud. But air molecules don't scatter all colors equally.

How much light of a certain color scatters when it bumps into an air molecule depends on the light's wavelength. The shorter the wavelength of visible light, the more the Earth's atmosphere scatters it. Violet, indigo, and blue light scatters much more than green, yellow, and red. This predominantly blue scattered light shines down from the sky to your eyes, and the sky looks blue.

The same Rayleigh scattering that makes the sky blue paints the sunset red. When the sun is low in the sky, the sunlight that shines directly from the sun to your eyes is much dimmer and redder than sunlight at high noon. At sunset, the sunlight that reaches your eyes has traveled at a slanting angle through the Earth's atmosphere. This path is longer by hundreds of miles than the path taken by the noontime sunshine. Since the light travels through more of the atmosphere, more light with shorter wavelengths is scattered away, leaving only the longer wavelength light—the orange and red— to reach your eyes.

The precise colors of the sky and the sunset vary, depending on what's in the atmosphere. If you compare the sky over the desert with the sky above the ocean, you'll probably find that the desert sky is a deeper blue, a saturated color containing less white. The air over the ocean carries tiny drops of water and particles of salt. Though these drops and particles are microscopic, they

There's no blue pigment in this blue eye. The blue of the iris comes from blue light that's scattered from minute protein particles. In some people's eyes, the protein particles in the iris grow larger with age. These enlarged particles scatter white light as well as blue. When that happens, the person's eyes become a paler shade of blue.

are considerably bigger than the molecules of air that scatter blue light. Rather than scattering one color selectively, these larger drops and particles scatter all colors equally, sending white light in all directions. This white light combines with the blue light scattered by air molecules to make the sky above the ocean a paler blue than the sky above the desert.

Scattering from air pollution and water droplets adds white to the skies above most cities. Some of this air pollution can also affect the colors of the sunset. On a smoggy day in Los Angeles, the sunset can be spectacular. Nitrous oxides in the smog absorb blue from the sunlight. Since blue light is both scattered away and absorbed, only red is left to reach your eyes, painting the sunset a dramatic crimson.

Natural phenomena can also drastically affect the sky color. A volcanic eruption, such as the 1991 eruption of Mount Pinatubo in the Philippines, can change the sky's color by sending thin clouds of sulfuric acid drops high into the Earth's atmosphere. The droplets of sulfuric acid scatter yellow and red light more than they do blue light. This scattering, combined with the scattering of blue light by air molecules, made the sky in the northern hemisphere paler from 1992 to 1994. By scattering away red and yellow light, these droplets can also, on rare occasions, tint the face of the full moon a startling blue-green.

But what does the blue moon have to do with Paul Newman's eyes, the blue jay feathers, and the blue-tailed day gecko? Though you can easily find many blue birds, blue reptiles, and blue-eyed people and animals, no one has ever found a naturally occurring blue pigment in any vertebrate species.

Blue-Tailed Day Gecko / William Neill

Structures in the skin of the blue-tailed day gecko scatter blue light, making the gecko's tail a beautiful blue. On other areas of the lizard's body, a layer of yellow pigment covers the structures that scatter blue, and the lizard's skin looks green.

If a person's eyes lack the layer of dark pigment, the light that passes through the layer of protein particles isn't absorbed. Instead, it reflects from the red blood in the blood vessels inside the eye. This reflected red light is strong enough to mask the scattered blue light, which is why albinos, individuals who lack the dark pigment known as melanin, have red or pink eyes.

The same mechanism—small particles that scatter blue light, backed by a dark pigment—is responsible for the blue of blue jay feathers and the blue tail of the blue-tailed day gecko. The blue color produced in this way is called Tyndall blue after the nineteenth-century British physicist John Tyndall, who was the first person to demonstrate that scattered light gives the sky its blue color.

Tyndall blue is modified when it is combined with layers of pigment. Some blue-eyed kittens, for example, grow up to be green-eyed cats. As the kitten ages, a layer of yellow pigment forms over the white protein particles of the kitten's irises, and its eyes become green.

The striking blue in the irises of Paul Newman's eyes comes from a layer of tiny white protein particles, backed by a layer of black pigment. The white particles scatter blue light back to the observer's eyes. Light that passes through the layer of white particles is absorbed by the layer of black pigment. The only light that reflects out of Paul Newman's eyes is the blue light that scatters from the white protein particles, so his eyes look blue.

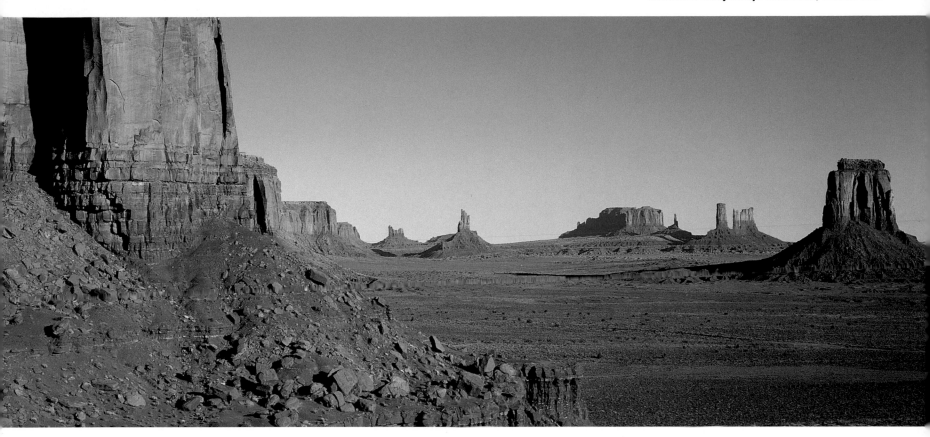

The combination of scattered light and absorptive pigment is common in the animal world. The green color of many frogs and lizards comes from a combination of Tyndall blue and yellow pigment. One bright green Australian tree frog bears the scientific name *Hyla coerulea*, or "blue tree frog," a name given to it by a biologist who saw only a preserved specimen. The yellow pigment had dissolved in the alcohol, leaving the frog's skin a brilliant blue.

In bird feathers, scattering and pigments combine to make a variety of colors. The parakeet, or budgerigar, commonly kept as a pet, has several color variations. Pet parakeets can be predominantly green, blue, yellow, or white. In the green birds, the color comes from three layers of material: a layer of yellow pigment, a layer of white particles that scatter blue, and a layer of dark pigment that absorbs the light that passes through the white particles. Blue parakeets have a recessive gene that prevents the accumulation of yellow pigment in the feathers. Yellow parakeets have a recessive gene that blocks the formation of a dark pigment layer. Without the dark background, the scattered blue light is not visible, and the birds are yellow. White parakeets have both recessive genes and therefore lack both the yellow pigment and the dark pigment.

The sky is usually a paler blue at the horizon than it is overhead. Tiny drops of water and particles of dust in the lower atmosphere scatter white light. This white light combines with the blue light scattered by air molecules to make a pastel blue.

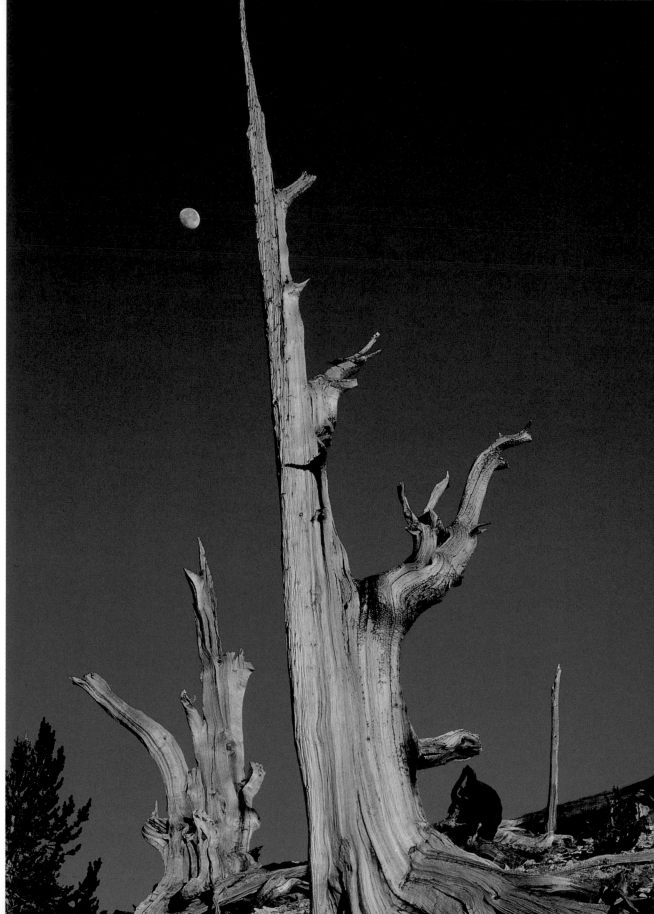

The deep pure blue sky over these ancient bristlecone pines fades at the horizon. Tiny drops of water and particles of dust that are suspended in the lower atmosphere scatter white light, making the sky paler at the horizon. The moon's face shines white, reflecting light from the sun. The golden light of the rising sun shining on the pines began as white light. As the light traveled the long and slanting path through the atmosphere, air molecules scattered the blue light, leaving a reddish-yellow light to reach the Earth's surface.

Moon over Bristlecone Pines, White Mountains, Inyo National Forest, California / William Neill

94

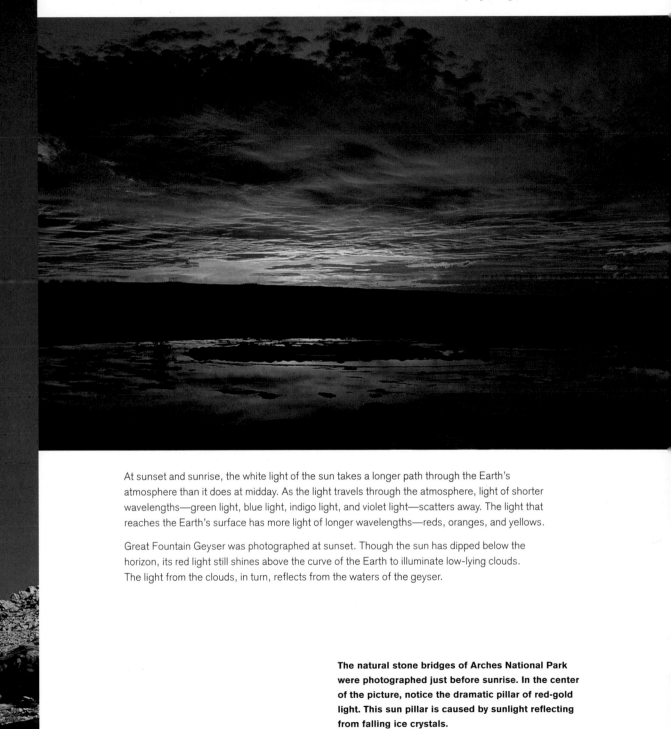

**Great Fountain Geyser at Sunset,
Yellowstone National Park, Wyoming** / William Neill

At sunset and sunrise, the white light of the sun takes a longer path through the Earth's atmosphere than it does at midday. As the light travels through the atmosphere, light of shorter wavelengths—green light, blue light, indigo light, and violet light—scatters away. The light that reaches the Earth's surface has more light of longer wavelengths—reds, oranges, and yellows.

Great Fountain Geyser was photographed at sunset. Though the sun has dipped below the horizon, its red light still shines above the curve of the Earth to illuminate low-lying clouds. The light from the clouds, in turn, reflects from the waters of the geyser.

The natural stone bridges of Arches National Park were photographed just before sunrise. In the center of the picture, notice the dramatic pillar of red-gold light. This sun pillar is caused by sunlight reflecting from falling ice crystals.

Sunrise, Arches National Park, Utah / William Neill ▶

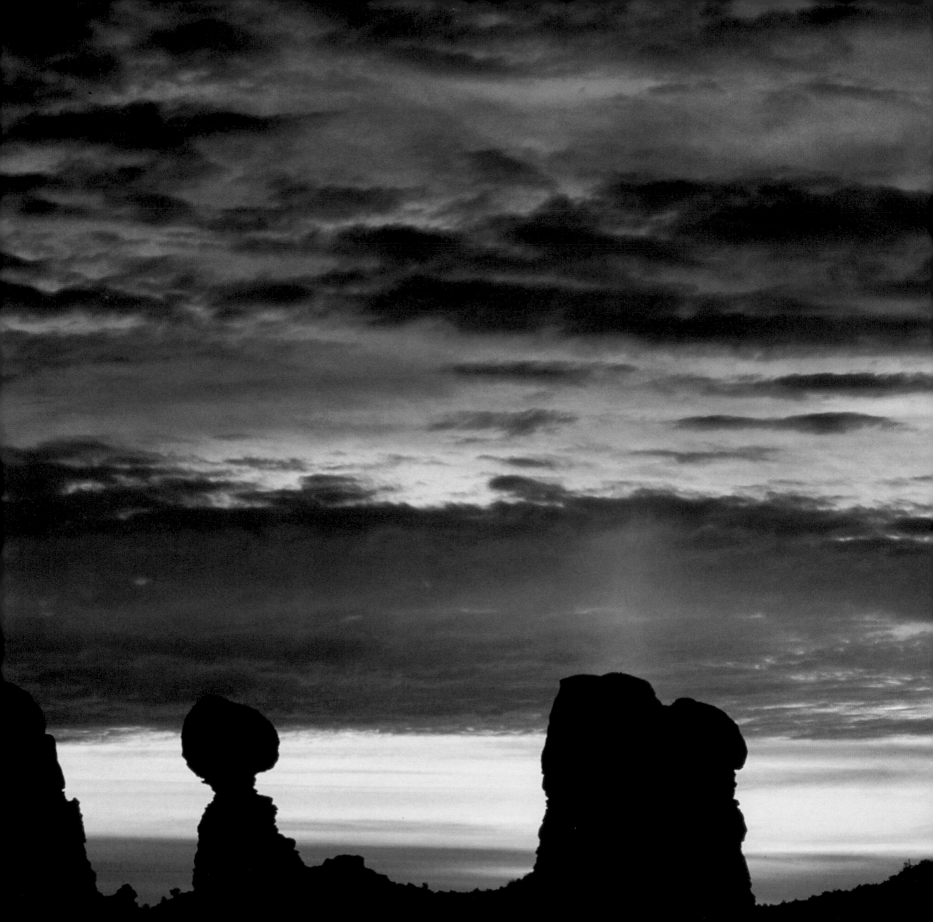

Sand Dunes, Death Valley
National Park, California / William Neill

In the early morning, the air usually contains more water than it does in the early evening. These tiny drops of water scatter white light from the rising sun and change the sun's crimson glow to a subtler pastel shade. That's why, as a general rule, sunrises are not as dramatically colorful as sunsets.

When a few thick cumulus clouds lie just above the horizon,

the rising sun may create a fan of bright and dark rays across the sky. These are called crepuscular rays or, in certain parts of Asia, the rays of Buddha. The dark rays are the shadows of the clouds; the bright rays are the shafts of sunlight passing between the clouds. If you see the rays of Buddha when no clouds are visible, don't be surprised. The clouds are just below the horizon.

Pailoa Bay, Waianapanapa State Park, Island of Maui, Hawaii / William Neill

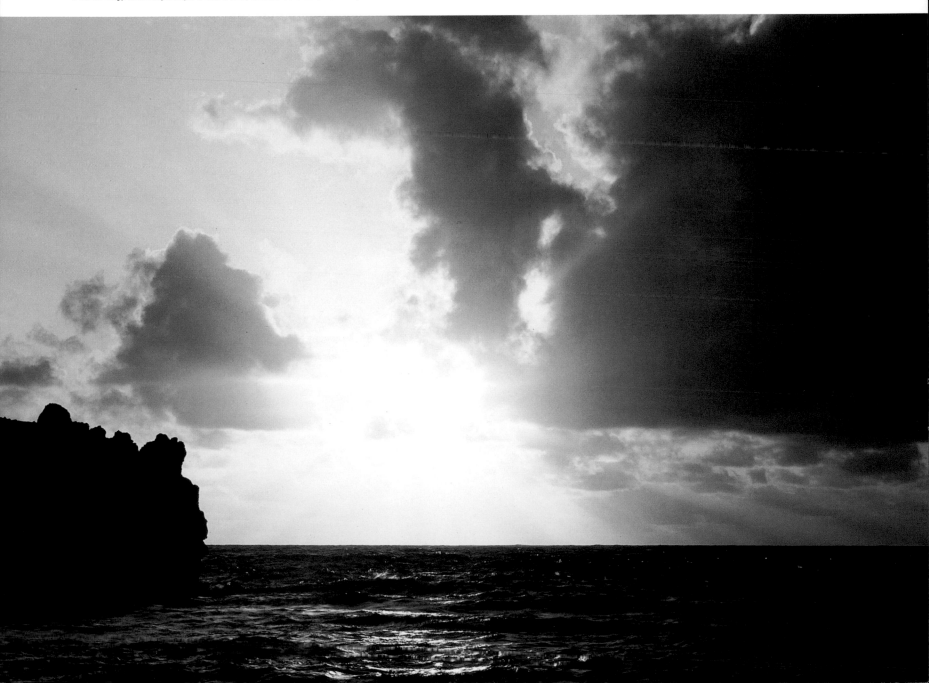

Most clouds look white because they are made of water drops or ice crystals that scatter all colors of light in all directions. But occasionally, when conditions are just right, thin, high clouds will scatter colored light, creating beautiful bands of color. These clouds, known as iridescent, or opalescent, clouds, are made up of uniform drops of water, each of which is about the same size or smaller than a wavelength of red light. The drops scatter light of different wavelengths at different angles, creating the colors shown here. Bands of color may appear at the edge of a cloud. When a cloud with small, uniform water drops passes in front of the sun, the colors circle the sun, a phenomenon known as a corona.

Iridescent Clouds / Pekka Parviainen

Corona / Pekka Parviainen

Burnt Trees and Shadows on Snow / William Neill ▶

Sunlight on snow scatters in all directions, making the snow look white. Shadows form where tree trunks block the direct sunlight. But light from the blue sky shines on the snow and reflects into the shadows, coloring them a delicate blue.

Ice Cave, Mendenhall Glacier, Alaska / David Muench

Frozen water absorbs some red light, making the interior of a cave in a glacier look blue. In addition, glacial ice contains tiny air bubbles, compressed by the weight of thousands of pounds of frozen water. These tiny bubbles scatter blue light, causing the cave to look even bluer. Ice cubes chipped from glaciers were once a popular fad in Japan. When the ice cubes melted in a drink, the compressed bubbles popped, producing lovely musical tones.

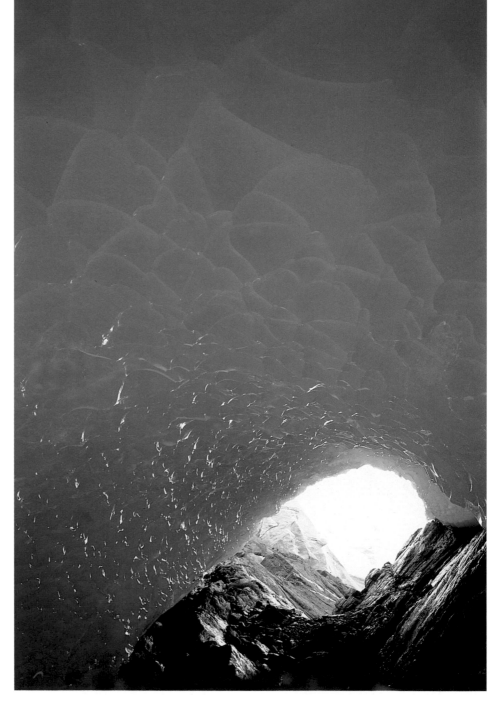

In this photograph, **water appears in many forms—** as clouds, as snow and ice, and as ocean water. Each form has its own characteristic color. Water droplets in clouds and ice crystals in snow scatter light of all colors, reflecting white to your eyes. Sunlight passing through layers of glacial ice loses its red light to absorption. At the same time, compressed bubbles in the ice scatter blue light, giving the iceberg a blue color. The ocean water contains microscopic plants, collectively called phytoplankton. The chlorophyll in these plants adds a green hue to the blue water.

Blue Iceberg, Le Conte Bay, Alaska
/ Stuart Westmorland

Though the air is clear, air molecules scatter blue light more than any other color. Sunlight scattering from the air molecules between the camera and the distant mountains tints the scene with shades of blue.

Grand Canyon National Park, Arizona / William Neill

Deep ocean waters look blue because water molecules absorb red light and scatter blue light back to your eyes. But this basic blue color can be modified. Areas of the ocean that reflect blue light from the sky look bluer than areas that reflect white light from the clouds. In shallow water, light reflecting from yellow sand combines with the blue of the water to make a greenish hue.

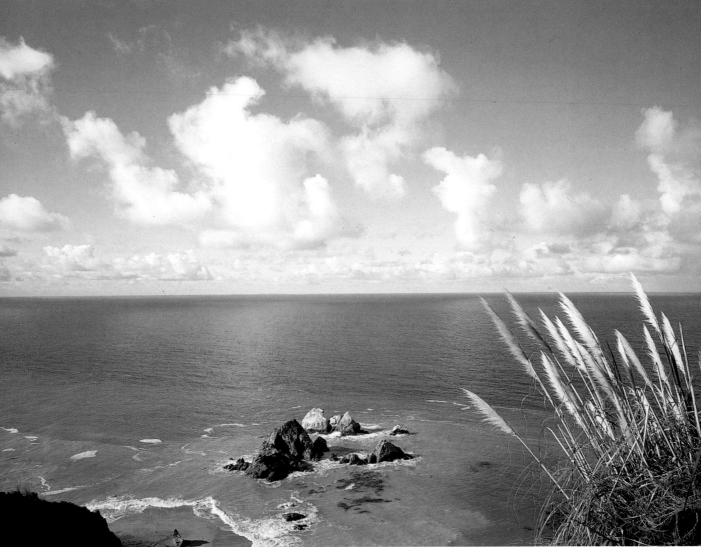

Big Sur Coast, California / William Neill

Havasu Falls and Travertine Formations,
Havasupai Indian Reservation, Arizona / William Neill

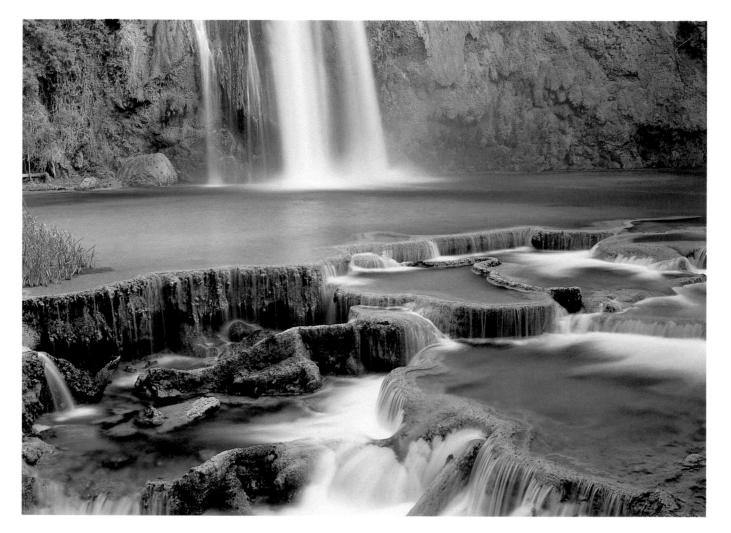

Green water usually indicates the presence of algae. In the pools
at the base of Havasu Falls, tiny balls of algae-covered limestone give
the water a greenish color. The water drops in the falls scatter white
light, just like the water drops in clouds, the ice crystals in snow, and
the tiny bubbles in the foam on top of a glass of beer.

Lakes formed by melting glaciers are sometimes a brilliant turquoise blue. The water contains tiny particles of rock, known as rock flour or glacial milk, formed by the movement of the glacier. If these particles of rock are smaller across than a wavelength of blue light, they will scatter blue light, giving the lake a vibrant color. If the particles are too large to scatter blue light, they will scatter white light, and the water in the lake will be a milky white.

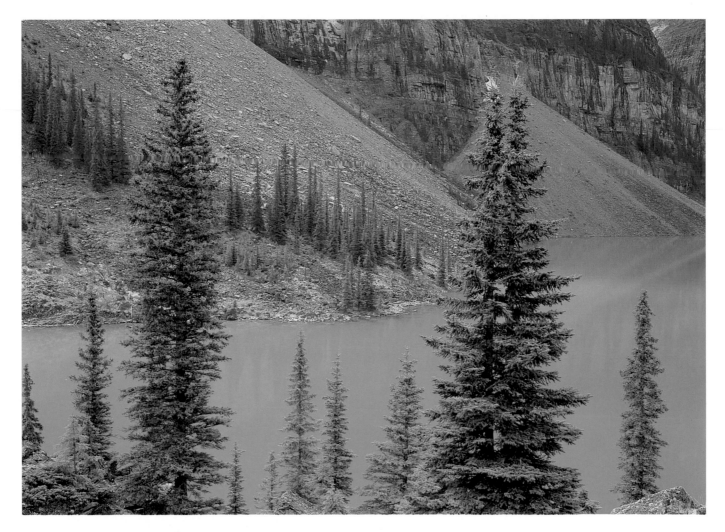

Moraine Lake, Banff National Park, Alberta, Canada / William Neill

Water Lilies in Bloom / William Neill

Polar Bear with Cubs, Manitoba, Canada / Kathy Bushue

Polar bears and water lily blossoms are white for the same reason.

The fur of the bear and the petals of the flower contain tiny structures that scatter all colors of light in all directions, reflecting white to your eyes. The polar bear's hair also acts like a fiber-optic cable. Some of the light that shines on the hair is channeled through the fur to the bear's dark skin, allowing the bear to absorb the warmth of the sunlight.

The cheeks of a mandrill are blue or bluish-white because protein particles in the skin scatter blue light. A layer of dark pigment beneath the layer of protein particles prevents other reflected colors from washing out the blue tones. Similarly, the chin of a fair-skinned man may have a bluish tint shortly after he shaves. That's because the roots of the beard hairs provide a dark background against which the scattering of blue light from protein particles in the skin can be seen.

Male Mandrill / William Neill

Little Bee-Eaters / Art Wolfe

These six little bee-eaters, native to sub-Saharan Africa, owe their colorful blues and greens to scattered light. Tiny air pockets in the protein of the feathers scatter blue light; a covering layer of yellow pigment colors some feathers green. As their name suggests, these birds feed on bees, hornets, and other stinging insects. At dusk, they often roost in groups, crowding together on a single branch.

Tiny particles in the skin of these lizards scatter blue light back to your eyes. The skin of most lizards and frogs also has particles that scatter blue light, but the particles are covered by a layer of yellow pigment. The combination creates shades of green.

Parson's Chameleon / Art Wolfe

Celestial 5 **colors**

Rainbows and Haloes

In ancient Greek mythology, the rainbow was the path that Iris, a divine messenger, followed on her journeys to the Earth.

**Celestial Colors:
Rainbows and Haloes**

The Shoshone tribe of North America believed the rainbow was a giant serpent that rubbed its back against the dome of ice that formed the sky. The particles of ice that the serpent scraped off fell as snow in the winter and rain in the summer. And the Bible identifies the rainbow as a symbol of God's promise to Noah to hold back the rain.

The glorious arc of color that sometimes follows a rainstorm has long been a source of wonder. For centuries, people have looked up and thought about what causes these colors in the sky and why they are associated with falling rain.

Next time you see a rainbow, take a moment to study this brilliant symbol of all that is colorful. Consider the rainbow colors: red, orange, yellow, green, blue, indigo, violet. Their order never varies: red is on the outside of the rainbow's primary arc; violet is on the inside. Compare the sky inside the rainbow's arc with the sky outside the arc. The sky inside the rainbow is always a little brighter.

Notice what happens when you walk toward the end of the rainbow in pursuit of the mythical pot of gold. As you move, so does the rainbow. The rainbow flees when you approach, keeping that pot of gold forever out of your reach.

The rainbow's mobility gives a clue to its nature. Though this arc of color may look like an object you could reach out and touch, it has no substance. The rainbow is made of light that is reflected into your eyes by the falling raindrops. When your eyes and brain detect that light, you see a rainbow.

In 1666, Isaac Newton determined that the rainbow's colors are all contained in the white light of sunshine. Newton passed a beam of sunlight through a glass prism, which separated the light into bands of color. When he let the colors shine through a second prism, they combined to make white light once again. The colors, Newton concluded, were in the white light to begin with. The glass did not add color to the light; it merely separated the white light into the colors that made it up.

Other experimenters figured out more about what happens when a beam of light shines into a prism or a drop of water. Whenever light shines at

◀ **Rainbow, Zion National Park,
Utah** / William Neill

Light Bending through a Prism / Nancy Rodger

When a beam of white light shines through a prism, the light bends. Each of the colors that make up white light bends at a different angle, and the colors spread out to make brilliant bands. This bending is called refraction, a word that comes from the same root as "fracture" and "fraction." All three words come from the Latin word *fractus,* which means "to break up." When sunlight bends through a glass prism or a raindrop, it refracts, or breaks up, into its component colors, all the colors of the rainbow.

SUNLIGHT

42°

an angle from one clear material into another, something strange happens. Rather than continuing in a straight path, the light bends. When it bends, different colors of light bend by different amounts. Red light bends a little when it passes from air into glass or water, green light bends a little more, and blue light bends even more.

That's why a drop of water can separate white light into many colors. When sunlight shines into a falling drop, the light bends at the boundary between the water and the air. Some of that light bounces off the opposite side of the drop and bends again on its way out of the drop. Whenever the light bends, each of the colors that make up the white light bends by a different amount. By the time all this bending and bouncing is done, the beam of white light has fanned out into rainbow colors.

What happens when a beam of white sunlight shines into a drop of falling water? The light beam bends when it moves from air to water and again when it moves from water to air. This bending separates white light into rainbow colors. The colored beams of light reflect off the opposite side of the drop. On their way out of the drop, the light beams bend again, and the colors separate still more.

Each of the rainbow colors bounces away from a raindrop at a slightly different angle relative to the path of the incoming light. Red light bends and reflects so that it leaves a water drop at an angle of 42 degrees or less. Green light bounces away from the drop at an angle of 41 degrees or less. Blue light reflects at 40 degrees or less. Because the water drop is spherical, the reflecting light forms a cone, with the drop at the tip. Each color makes its own cone of light, and all these cones fit inside each other, with the red cone on the outside. The water drop is at the tip of all these cones of colored light.

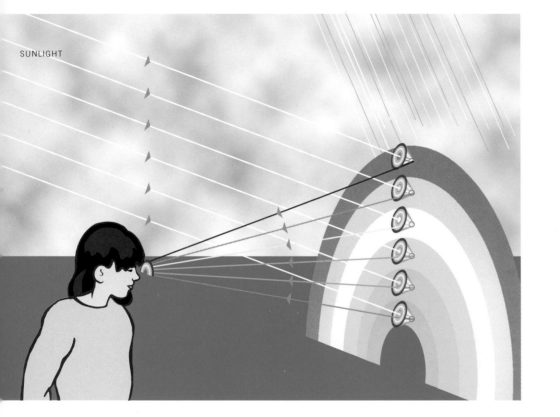

SUNLIGHT

The graceful curve of the rainbow is made up of colored light reflecting from many water drops. To see a rainbow, you must stand where your eye can intercept this colored light. If a line from your eye to a water drop makes a 42-degree angle relative to the path of the incoming sunlight, that drop will reflect red light to your eye.

If the angle is 40 degrees, that drop will reflect blue light. One set of drops reflects red light to your eyes; another set of drops reflects green light; another set reflects blue light.

That's why a rainbow's position depends on where you're standing. If you take a step to one side or the other, you'll see a different rainbow, reflecting from a different set of raindrops. In fact, there are as many rainbows as there are observers. A friend standing beside you doesn't see the same rainbow that you see.

To see a rainbow, you have to be standing where your eyes can intercept the colored light that bounces off the water drops. To find a rainbow in the mist of a waterfall or the spray of a sprinkler, for instance, you need to position yourself so that the sun is shining over your shoulder. The sun shines into the drops and bounces back in your general direction. If you move so that you are facing the sun, the rainbow will disappear.

This knowledge can help you know when to look for a rainbow in the sky. When the sun is low in the western sky, sunlight shining on a thunderstorm to the east of you makes a rainbow that you can see for miles. At the same time of day, you won't see a rainbow in a thunderstorm to the west of you. That doesn't mean that the raindrops in the western storm aren't making a rainbow. Though you aren't in the right position to intercept the rainbow light, an observer standing on the other side of the storm might be.

You can find a rainbow whenever you have sunlight and falling water drops. Stand with the sunlight shining over your shoulder onto the spray of a lawn sprinkler or the mist from a waterfall. The rainbow will be 42 degrees away from the shadow of your head. To find this angle, hold your arms out straight and spread your fingers wide, touching your thumbs together. Position the tip of one little finger in the center of the shadow of your head. You'll see a rainbow where the tip of your other little finger lines up with the spray.

42°

Hundreds of years ago, someone noticed where rainbows appear—and used this information to help predict the weather. An ancient German folk rhyme translates: "A rainbow in the morning is the shepherd's warning; a rainbow at night is the shepherd's delight." In Europe, changes in the weather travel from west to east. Since the rainbow always appears opposite the sun, a morning rainbow means that there's rain to the west and wet weather is coming. An evening rainbow means that there's rain to the east, but no rain coming.

Though the rainbow is the best-known example of colors in the sky, it isn't the only one. Light bending through ice crystals high in the atmosphere cancreate dramatic arcs and spots and rings of color.

Light bending through the Earth's atmosphere is responsible for the green flash, or green ray, the green light that sometimes appears just as the sun sets or just as the rising sun peeks above the horizon. All of these colors are caused by light bending as it passes from one clear material to another.

The rainbow also tells you something about where the rain is falling. In this picture, the rainbow disappears behind the trees, which indicates that the raindrops reflecting the colored light are also behind the trees.

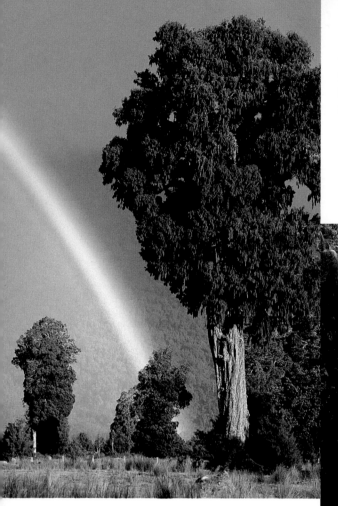

Rainbow over Trees / Warren Jacobs

Notice that the sky is darker outside the arc of this rainbow. Most of the light reflecting from the raindrops ends up inside the rainbow's arc, making this area of sky bright.

The brightness of the colors in a rainbow tells you the size of the water drops that produced it. Large raindrops produce a brilliant rainbow with bands of vivid colors. Smaller water drops produce rainbows with bands of color that merge, making colors that aren't as pure. In rainbows produced by tiny drops of mist, the colors overlap to make almost colorless arcs of brightness.

Rainbow in Narada Falls, Mt. Rainier National Park, Washington / William Neill

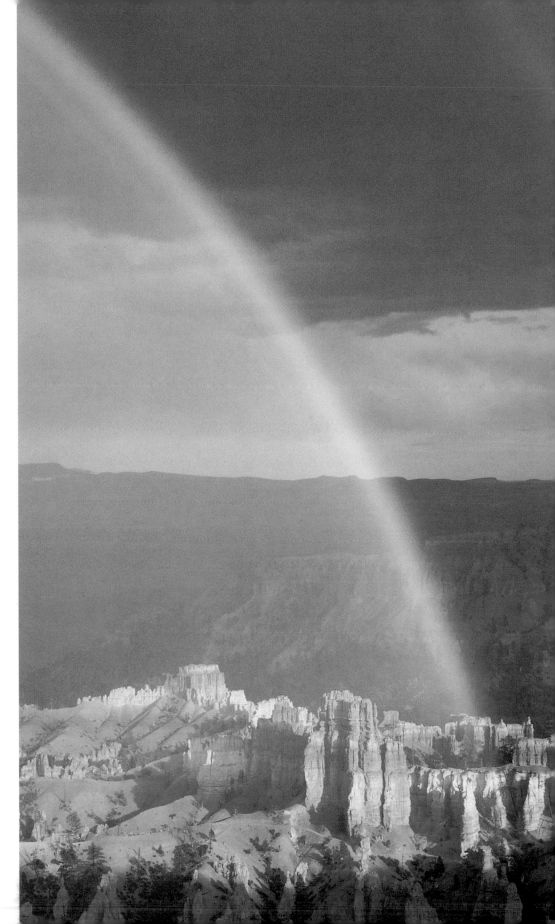

Double Rainbow, Bryce Canyon
National Park, Utah / William Ncill

Though the colors of a rainbow are actually
continuous, with one blending into the next,
Isaac Newton identified seven colors in
the rainbow, choosing seven because they
matched the number of notes in the musical
scale. These colors are always in the same
order: red, orange, yellow, green, blue, indigo,
and violet. To remember the order of the
rainbow colors, think of the name Roy G. Biv.
Each letter in the name is the first letter of
a rainbow color in its proper order.

If you study a rainbow carefully, you can often

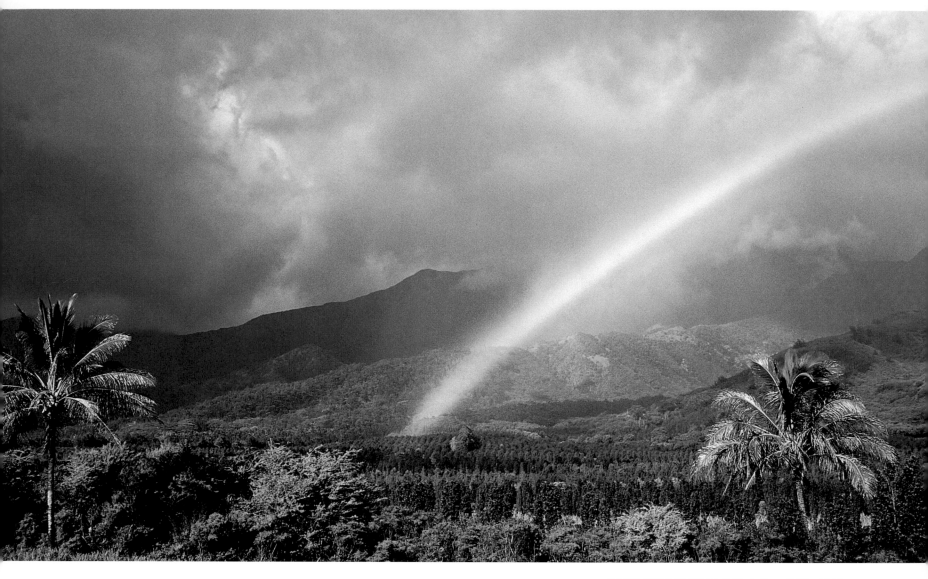

Double Rainbow, Island of Maui, Hawaii / David Olsen

see a faint secondary rainbow outside the bright primary rainbow.

Double Rainbow, Yosemite National Park, California / William Neill

In the secondary rainbow, the order of the colors is reversed, with red on the inside of the arc and violet on the outside. The light that makes the primary rainbow enters the raindrop and bounces just once before it gets to your eye. The dim secondary rainbow is made by light that reflects twice before it leaves the water drop.

If you see a rainbow and can't find a secondary rainbow, here's a tip to help you look for it. The secondary rainbow is separated from the primary rainbow by a distance of about 9 degrees. If you hold a hand at arm's length and make a fist, the width of your fist is about 10 degrees. Look for the secondary rainbow just one fist-width away from the primary rainbow.

Halo around the Sun / William Neill

Sunlight shining through ice crystals high in the Earth's atmosphere bends to make a halo around the sun. The halo may be pale red on its inner edge and pale blue on its outer edge, but the colors won't be as bright as the colors of a rainbow. The sky is dark inside the halo and brighter outside. If you watch the sky frequently, you're likely to see a halo like this one.

Lunar Rainbow, Yosemite National Park, California / William Neill

Moonlight is sunlight reflecting off the face of the moon. When light from the full moon hits drops of spray from Yosemite Falls, the reflecting light makes a rainbow—but the colors are too dim for your eyes to detect. This photograph, taken with an exposure time of about two minutes, collected more light than would be visible to the human eye, revealing the colors of this rainbow produced by moonlight.

When moonlight bends through ice crystals, a halo may form around the moon. According to weather folklore, "A ring around the moon means rain soon." The ice crystals that bend light to make a halo are often part of high, thin cirrus clouds that precede a warm front. Since a warm front is usually accompanied by rain, the folk saying is often true.

Halo around the Moon / Pekka Parviainen

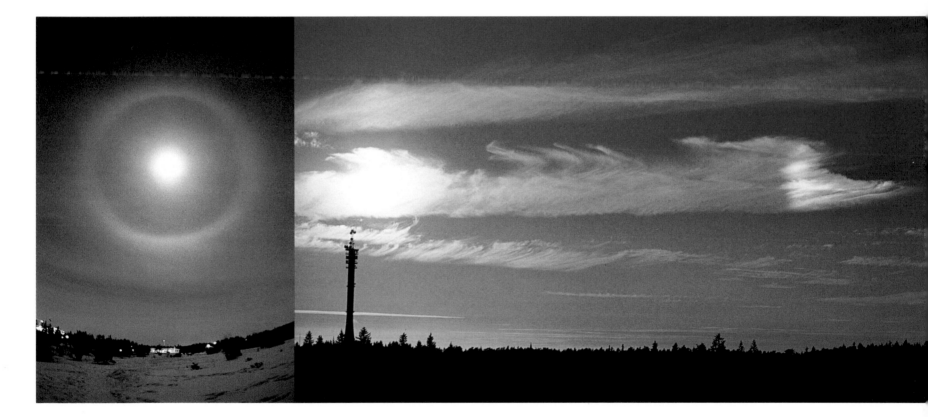

Sun Dogs / Pekka Parviainen

Brightly colored sun dogs follow the sun as it rises or sets. Like halos and arcs, sun dogs are formed when sunlight bends through ice crystals high in the atmosphere. These bright spots of color are sometimes mistaken for alien spacecraft—the red end of the sun dog may look like rocket exhaust coming from the blue-white body of a UFO.

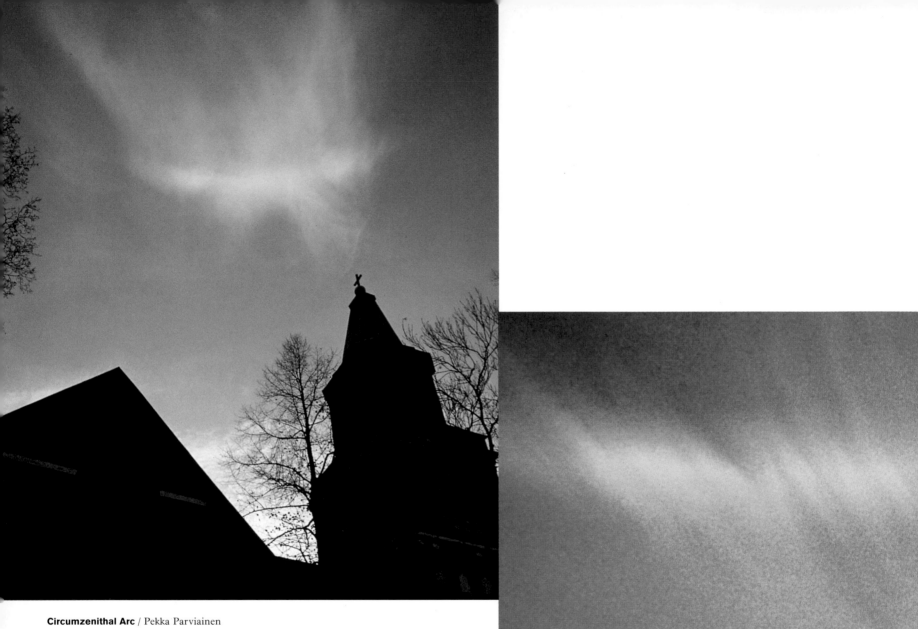

Circumzenithal Arc / Pekka Parviainen

A few times each year, an arc of colors appears in the sky overhead. It's curved upward, like a smile, and its colors are more vivid than a rainbow. This is the circumzenithal arc, an arc that circles partway around the zenith, the point directly above your head. It appears only when the sun is low in the sky, no more than 32 degrees above the horizon. In most of the United States, that means the circumzenithal arc appears only for a few hours after dawn or before sunset.

When the sun is high overhead, you may see another rare phenomenon known as the circumhorizontal arc. This ribbon of colors appears just above the horizon and looks like a flattened rainbow, with red on the top and blue on the bottom.

Both the circumhorizontal arc and the circumzenithal arc are created by sunlight passing through ice crystals high in the atmosphere. Some 30,000 feet above the Earth's surface, in the cold air at the boundary of the stratosphere, six-sided ice crystals may form. These crystals may be wide and flat, like hexagonal tiles, or they may be long and thin, like unsharpened pencils.

When the sun is high, sunlight shines down into the top of each crystal and bends to shine out through one of the sides. Like a prism, the ice crystal separates the white light of sunlight into brilliant colors, making the circumhorizontal arc. When the sun is low in the sky, sunlight shines into the side of the crystal and bends to shine out the bottom, forming the circumzenithal arc.

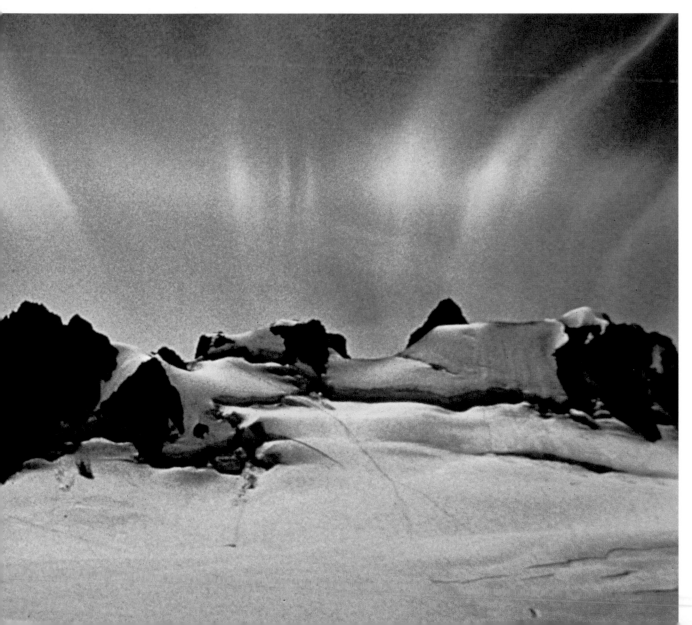

Circumhorizontal Arc / Steven Hodge

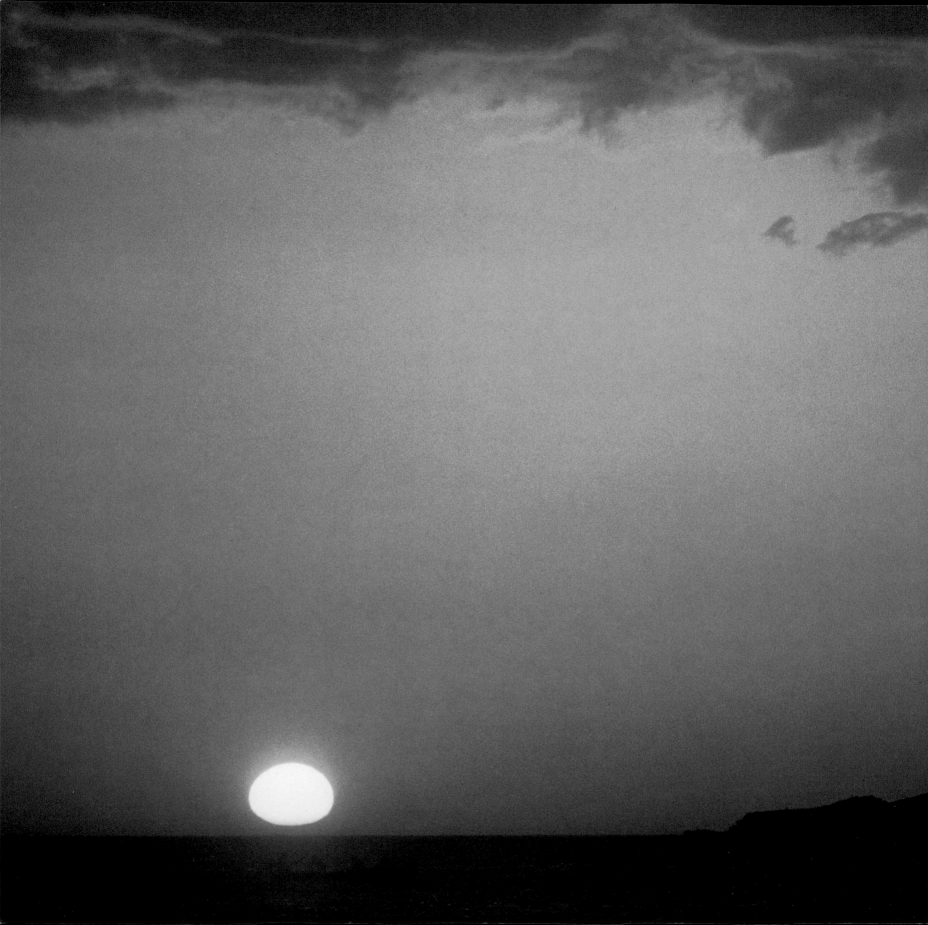

Fishing Boat at Sunset, Goa, India / William Neill

The setting sun often seems to flatten as it sinks toward the horizon. That's because the sun's light is bending as it moves from the thin outer layers of the Earth's atmosphere to the denser atmosphere near the planet's surface.

Green Flash / Pekka Parviainen

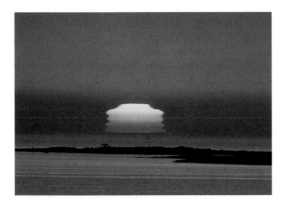 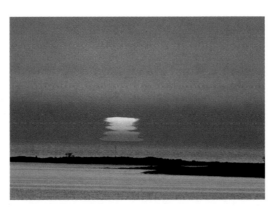 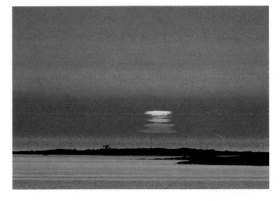

Under the proper conditions, the last ray of light from the setting sun is a brilliant green, rather than the crimson red you might expect. Because the Earth's atmosphere bends sunlight, it acts like a prism, dividing the white image of the sun into solar images in all the colors of the rainbow. If you glance at the setting sun, its brilliance makes distinguishing these overlapping images impossible.

But when the sun dips low enough in the sky, the horizon blocks out most of the sun, letting you catch a glimpse of the uppermost image. Since the atmosphere removes much of the blue, indigo, and violet light, the uppermost image is green—and that's the last light you see.

The conditions for seeing the green flash, or green ray, with an unaided human eye occur only a few times out of every ten sunsets over a distant unobstructed horizon.

Afterword by William Neill

**Mountain Ash Berries, Clingman's Dome,
Great Smoky Mountains National Park,
North Carolina** / William Neill

As an artist and an observer of nature, I have always responded strongly to color. Even though my favorite photographers are known for their black-and-white imagery, when I make photographs, the colors I experience at the moment of exposure are integral to the image.

Color photography has its artistic dangers since both the photographer and the viewer can easily be seduced by the emotions evoked by color. Think of the color red. Although our reaction to this color is often intense, a good photograph featuring the color red evidences attention to composition, lighting, and other elements that make it successful. A common mistake of the amateur photographer is to respond only to the color of a subject and ignore the other aspects critical to creating a strong image. When these elements are thoroughly considered, an image of red roses—though often epitomizing the photographic cliché—can transcend the mundane. Even more important, the photographer can bring a personal vision and style to his or her work.

Normally when I photograph, I do not think consciously about color, but respond intuitively to color, as well as design and light, the other elements that draw me to a subject. For this book, however, I had to concentrate especially on revealing color. I was given a long list of about eighty subjects that needed to be illustrated. Pat Murphy of the Exploratorium knew what she wanted to say with each photograph and suggested how and where to find the subjects. This process required much research and exploration, leading me to such diverse locations as the flower market in San Francisco, alpine lakes in the Canadian Rockies, the deserts of the American Southwest, and the supermarket. Looking for solar haloes, lunar rainbows, a perfect bunch of Concord grapes, or a dense field of wildflowers was a wonderful process of discovery. The greatest challenge was to make artistic images that also illustrated the scientific principles. Many efforts failed and weren't suitable for the book. I have tried to bring my personal style to all of the photographs that appear in the book.

Like most of us, I had never thought much about how we see colors. As with the last book I worked on with the Exploratorium, *By Nature's Design,* my eyes were opened on this project to a new understanding of how the world works. For anyone with a keen sense of wonder, *The Color of Nature* is an enticing voyage.

Technical Notes The diversity of subjects in this book required that I use techniques particular to macro photography, landscape photography, aerial photography, and wildlife photography. Working on this project allowed me to apply often-used techniques as well as develop new ways, at least for me, to photograph the colors in nature. Both in my choice of equipment and in my images, my emphasis is on simplicity.

Since the primary subject of this book was color, I needed to be aware of my choice of film and filters so that my images illustrated the color phenomena or subjects most clearly and with impact. Fine-grained color transparency film, most often Fujichrome Velvia, ensured that the intensity of what I saw came through. I used filters sparingly. The only filters I own are 81A or 81B warming fil-

ters, polarizing filters, and a pair of Singh Ray graduated neutral density filters. The polarizing filter was especially useful in revealing the depth of color in such shiny objects as leaves or rocks, like the photograph of autumn foliage on page 33 and the image of the rain forest on page 31. The warming filters help increase the warmth of a scene or balance out excessive blue light, as in shaded subjects photographed on a sunny day. The photograph of Artist's Palette on page 46 was made using an 81A filter after the sun set behind the mountains, which were behind me. The expanse of blue sky was reflecting into the shadowed formations. The filter negated the blue lighting conditions so that the colors in the photograph were more accurate. For the image of burnt trees and shadows on pages 17 and 101, I did not use a warming filter since I wanted to preserve the wintry look of the blue shadows.

I used two camera formats: 4x5 and 35mm. A Wista 4x5 metal field camera is my choice for most landscape photography. My lenses include 90mm, 150mm, 210mm, and 360mm focal lengths, with the 210mm and 150mm my most frequent selections. The large viewing screen and slow speed of

a view camera lend themselves to a precise and contemplative approach to composing images. I have used Kodak Ektachrome, Polaroid ProChrome 100D, and Fujichrome Velvia Quick-load in 4x5 over the years, and all three film types are represented in this book.

For 35mm equipment, I used a Canon EOS-1N camera and an assortment of lenses including the 20-35mm f/2.8, 28-70mm f/2.8, 50mm f/2.5 Macro, 80-200mm f/2.8, 24mm and 90mm Tilt/Shift, and 300mm f/4 focal lengths. A few older images were made with Nikon equipment, but the more recent images were made with Canon equipment.

I used Canon's Tilt/Shift lens, the 24mm and 90mm, to solve special problems. To make the poppy field image on page 24 the tilt function on the 24mm allowed me to maintain great depth of field on a day when the wind was blowing constantly at 30–40 miles per hour. By tilting the lens forward, as I often do with a view camera, I could choose the widest aperture and expose the film at 1/1500 of a second to stop the movement of the flowers. It was not possible, however, to use the view camera, because its large size and profile make it unstable in windy conditions. The iron pyrite photograph on page 85 was made with a Canon 90mm Tilt/Shift lens combined with a Canon EF25 extension tube. The colors and shimmering quality of the stone were much more evident at an oblique angle, and the ability to tilt the lens forward allowed me to compose at a low angle and make a sharp image that revealed the reflective colors of the pyrite.

For the macro photographs, I used three types of lighting: natural light outdoors, natural light coming indoors through a window, and flash. Whenever possible I rely on natural light. For found still-life subjects, the soft but directional light coming from a single window is my preferred approach, and was utilized for the photographs of the abalone shell on pages 13 and 76, the orchid on page 25, and the red roses on page 18–19. A flash was employed most often when I needed to photograph inside, where only artificial lights were available.

The images of lava, photographed on the Island of Hawaii, were the most thrilling ones to make. Watching the process of creation was unforgettable. The molten lava flows into the ocean, and as it turns to stone, the island grows. I needed no special techniques. I tried different shutter speeds to see the different results in the motion of waves, flowing lava, and steam. I also did an occasional tap dance when my feet got too hot! With this idea of experimentation—be it with shutter speeds, camera angle, or exposure—in combination with a sense of wonder and adventure, the amateur photographer can best improve his or her work. This process promotes the discovery of a personal way of seeing.

William Neill

Acknowledgments

At the Exploratorium, no one works alone. This book would not exist without the efforts of many members of the Exploratorium staff and friends of the Exploratorium. Working from an intimidating list of possible images, William Neill managed to find some of nature's most elusive colors and capture them on film. Judith Dunham provided invaluable assistance in shaping the book and ensuring that technical information was presented in a way that the layperson could understand. David Barker translated technical details into diagrams of remarkable clarity. Ruth Brown and Mark Nichol read the manuscript with great care to make certain that all the hyphens, commas, and dashes were in their proper places. Ellen Klages and Gary Crounse provided research assistance when we needed it most. Kurt Feichtmeir and Megan Bury kept us on schedule and provided endless support—both moral and administrative. And of course, none of this would have been possible without the efforts of Caroline Herter and Emily Miller of Chronicle Books. Thank you all for your assistance.

— Pat Murphy and Paul Doherty

I would like to thank all those who encouraged and supported my photography over the years. This book would have been impossible without Pat Murphy, who, with few words, makes scientific concepts perfectly clear in her text. She, along with Paul Doherty, provided me with ideas and feedback on what subjects would best illustrate the principles of color for this book. Kurt Feichtmeir was instrumental in keeping us organized and on course. I thank the people at Chronicle Books, Todd Foreman, and Judith Dunham for pulling all our efforts together into a beautiful book. Dave Metz of Canon USA provided valuable support in the form of camera equipment. Finally, I wish to thank my wife Sadhna for her research, for all her efforts spotting solar haloes, rainbows, and other color phenomena, and for her unfailing encouragement.

— William Neill

Photography and Illustration Credits

In addition to the photographs by William Neill, *The Color of Nature* includes the work of the following photographers. All photographs remain under the copyright of the photographer except as otherwise noted.

Heather Angel/Biofotos: pages 21, 78

Robert E. Barber/Global Pictures: page 112

William S. Bickel: page 57

Kathy Bushue/Tony Stone Images: page 109

David R. Frazier/Tony Stone Images: page 61

J. P. Harrington, K. J. Borkowski/University of Maryland and NASA: page 63

Jeff Hester/Arizona State University and NASA: page 63

Steven Hodge/©Alistair B. Fraser: page 128–129

Johnny Horne: page 59

Warren Jacobs/Tony Stone Images: page 120

Dennis Kunkel/MicroVision, Honolulu, HI: page 73

Frans Lanting/Minden Pictures: pages 84, 85, 86

W. G. May: page 76

Joe McDonald/Global Pictures: page 81

David Muench/Tony Stone Images: page 102

NASA: pages 59, 64

David Olsen/Tony Stone Images: page 122

Pekka Parviainen/Polar Image: pages 64–65, 66, 67, 68–69, 100, 127, 128, 131, 132–133

Jeffrey Rich/Global Pictures: page 51

Nancy Rodger/©Exploratorium: page 117

Ron Sanford/Tony Stone Images: page 41

Susan Schwartzenberg/©Exploratorium: page 74

Stuart Westmorland/Tony Stone Images: page 103

Art Wolfe/Tony Stone Images: pages 39, 45, 111, 113

Illustrations and diagrams are from the Exploratorium.

David Barker/©Exploratorium: pages 73, 74, 75, 117, 118, 119

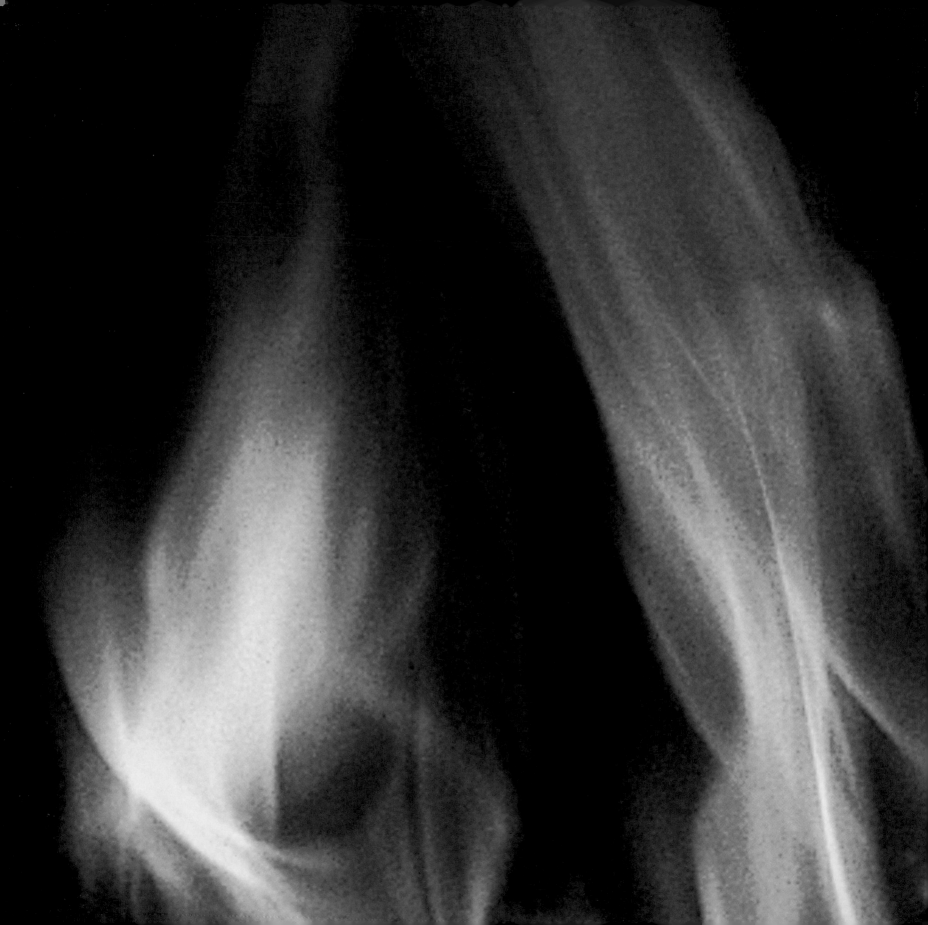

Suggested Reading

If you would like to know more about the Exploratorium, our exhibits, and our programs, check out our site on the World Wide Web. Our address is http://www.exploratorium.edu.

If you would like to know more about the physics and chemistry of natural colors, a good starting place is *Color: Why the World Isn't Grey* (Princeton University Press, 1983) by Hazel Rossotti. Rossotti offers clear and thorough explanations for readers who lack a scientific background. For readers who are prepared to tackle a more advanced treatment of the topic, we suggest two sources: the article "The Causes of Color" by Kurt Nassau in *Scientific American*, Vol. 243, No. 4 (October 1986), and Nassau's book, *The Physics and Chemistry of Color* (John Wiley and Sons, 1983).

You can find more information on the biological functions and evolution of natural colors in *Color in Plants and Flowers* (Everest House, 1978) by John and Susan Proctor, and *Animals and their Colors* (Crown Publishers, 1974) by Michael and Patricia Fogden. To learn more about the role of color in the interactions and coevolution of insects and flowers, we recommend *Insects and Flowers: The Biology of a Partnership* (Princeton University Press, 1991).

If you are interested in the colors produced by lightning, look for *Lightning and its Spectrum* (University of Arizona Press, 1980) by Leon E. Salanave.

To find out more about the shimmering iridescent colors of soap films, consult *The Science of Soap Films and Soap Bubbles* (Dover Publications, 1992) by Cyril Isenberg. If you want to know more about iridescent birds and insects, we recommend *The Splendor of Iridescence* (Dodd, Mead, and Company, 1971) by Hilda Simon.

For more information on colors (and other optical effects) that appear in the sky, we suggest *Color and Light in Nature* (Cambridge University Press, 1995) by David K. Lynch and William Livingston, *Rainbows, Halos, and Glories* (Cambridge University Press, 1980) by Robert Greenler, and *The Nature of Light and Colour in the Open Air* (Dover Publications, 1954) by M. Minnaert. Optical effects are also discussed in two popular books by Craig F. Bohren: *Clouds in a Glass of Beer* (John Wiley and Sons, 1987) and *What Light through Yonder Window Breaks* (John Wiley and Sons, 1991).

Finally, for anyone who wants a thorough and detailed discussion of all aspects of light and optics, we recommend the textbook *Seeing the Light: Optics in Nature, Photography, Color Vision, and Holography* (Harper and Row, 1986) by David S. Falk, Dieter R. Brill, and David G. Stork.

Flames of a Campfire / William Neill

Index